Forward astronaut Capt. Edgar D. Mitchell, Ph. D.

ETHER-TECHNOLOGY

A Rational Approach to Gravity Control

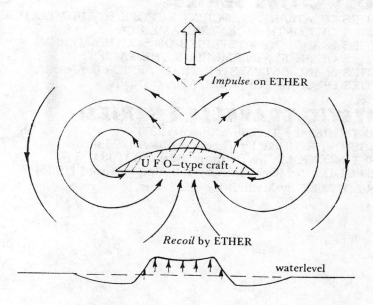

Impulse on ETHER

U F O—type craft

Recoil by ETHER

waterlevel

by Rho Sigma

THE UNDERGROUND CLASSIC IS BACK IN PRINT!

ETHER-TECHNOLOGY
A rational approach to gravity-control

by
Rho Sigma

Published by Rho Sigma

ETHER-TECHNOLOGY
A Rational Approach to Gravity Control

This printing March 1996

ISBN 0-932813-34-8

Published by
Adventures Unlimited Press
One Adventure Place
Kempton, Illinois 60946 USA

Printed in the United States of America

ACKNOWLEDGMENTS

The author wishes to make grateful acknowledgments for the individual research contributions of the following persons and friends in the USA and abroad:

Capt. Edgar D. Mitchell, Ph.D.	USA
Mr. Thomas Townsend Brown, P.E.	USA
Dr. Erwin Saxl	USA
Dr. h.c. Galen T. Hieronymus	USA
Dr. Daniel Fry	USA
Mr. James B. Beal, P.E.	USA
Mr. James M. McCampbell	USA
Mr. Bruce De Palma	USA
Mr. George W. Meek	USA
Mr. Jan P. Roos	USA
Dr. Henry F. Pulitzer	England
Mr. John R.R. Searl	England
Mr. William Whamond, P.E.	Canada
Mr. C. B. Wynniatt, P.E.	New Zealand
Dr. Georg Unger	Switzerland
Monsieur Henry Durrant	France
Prof. Dr. Marco Todeschini	Italy
Sig. Hellmuth Hoffmann	Italy
Herr Gotthard Barth, physicist	Austria
Dr. Wolfgang Fragner	Germany, BRD
Dr. Burkhard Heim	Germany, BRD
Prof. Hermann Oberth, Dr. h. c.	Germany, BRD
Herr Hubert Malthaner, Oberstudienrat a. D.	Germany, BRD
Herr Wilhelm Laun, Dipl.Ing.	Germany, BRD

My heartfelt thanks for editing of the material to Mrs. Violet M. Shelley, and to Mr. Roland Klemm for re-editing some new chapters.
To the A.R.E. and Edgar Cayce Foundation, for permission to quote from the "Edgar Cayce Readings";
To the F.I.L., (Fellowship of the Inner Light), Virginia Beach, Va., for permission to quote from the "Paul Solomon Readings";
And to all those in other spheres of consciousness whose inspirations made this publication possible.
Last, but not least, to my very brave and precious dear wife, whose never-ending support made it a reality.

CONTENTS

PREFACE

Knowledge as a resource

"Those who have handled sciences have been either men of experiment or men of dogma. The men of experiment are like the ant; they collect and use; the reasoners resemble spiders, who make cobwebs of their own substance. But the bee takes a middle course; it gathers its material from the flowers of the garden and of the field, but transforms and digests it by a power of its own."

(Sir Francis Bacon, *Novum Organum*, 1620)

The two crucial faults Sir Francis Bacon observed in most of his contemporaries are still with us. On one side are rationalizing philosophers (the spiders), whose theories have little relation to observed phenomena. On the other side are "men of experiment" (the ants), who are more or less content to collect facts in various categories, with little interest in integrated theory.

It was Bacon's genius to clarify the complex relationships between theory and experiment (the way of the bee). This cornerstone of scientific inquiry forms the most important step in transforming knowledge into a true resource for the improvement of human society.

The major portion of this book contains reports of officially little known experiments, observations, and other work carried on privately in small laboratories and by individuals throughout the world for some decades—apparently with little intercorrelation or communication as to how their work relates to other efforts being generated simultaneously elsewhere. Progress in borderland areas is generally painfully slow, and some conjecture is offered as to how these experiments and observations may be related in a meaningful, useful manner to the innovative and inspirational theories of brilliant "loners."

9

Since an understanding of related UFO observations seems essential in any investigation of new energies and gravity-technologies, one chapter in the forthcoming second book of this study series will present an overview of the observed propulsion aspects of UFO's and the macabre history of the official handling of the problem which will give the reader an appreciation of the calibre of the people involved and the thoughts which have gone into the investigation of the UFO enigma and related energy problems generally. The intelligent reader may thereby learn more in an area of human experience in which the "modus operandi" has for years been one of controversy, ridicule, suppression of data, and personal embarrassment. We trust that, with the publication of this work, this period of awkwardness and disbelief will finally be laid to rest and the genesis of a new consciousness may—hopefully —pave the way to a new science and technology worthy of the coming New Age.

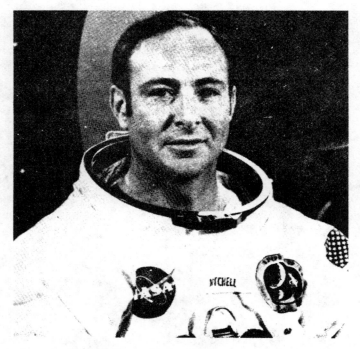

"Apollo 14" Astronaut Mitchell in spacesuit before
starting on his Moon voyage

FOREWORD—CAPT. EDGAR D. MITCHELL, Ph.D.

"A CHANGE OF CONSCIOUSNESS"

"The view from space which I was privileged to have of our planet is an event that has profoundly affected my life. The pictures you have seen in books, magazines and on television help give some sense of that awesome but magnificent sight. But photography has its limits and a photograph cannot tell you of the way my philosophy and my committment to philosophy has been changing since that voyage to the moon." Thus began an address written by the former U.S. astronaut, Capt. Edgar D. Mitchell, and presented August 25, 1972, to the 21st International Conference on Parapsychology and the Sciences in Amsterdam by my colleague, NASA Engineer James B. Beal.

"To see a small, majestic planet Earth floating in a black sky—in its blue and white splendor is something you cannot forget. It stays with you profoundly, long after the splashdown, the hero's welcome and the parades have been forgotten. Because the view from space has shown me—as no other event in my life has—how limited a view man has of his own life and that of the planet.

"Man fancies himself the highest development in nature—the ruler and most intelligent of creatures on Earth. About that notion, I have strong reservations. If animals could communicate with us, and some experiments going on now indicate they might some day—I will suggest that the first thing they would say is; how glad they are not to be human. Because no other animal commits the atrocities and stupidities that men do. In our surfeit of knowledge but paucity of wisdom, we've come near the brink of global destruction. The possibility of nuclear Armageddon is very real. The possibility of our extinction due to environmental pollution is just as real and only a little bit slower than using fission or fusion. Certainly these man-made threats to life on Earth cast some doubt on the supremacy of human intelligence.

13

"So the situation is desperate, and I became acutely aware of that as I gazed at Earth from a quarter of a million miles away. It put a new perspective on things far beyond just the visual dimension. I could see the potential of the planet, if it were to function in accordance with the natural design of the Universe. I could see what Earth can be if Man could choose to make it so. Yet I knew back on Earth people were fighting, stealing, raping, deceiving—totally unaware of their individual part, or responsibility for, the possible future of the planet; just living unconsciously or distrustfully or greedily or callously or apathetically. And at the same time other people were living in poverty, ill-health, near-slavery, starvation, fear and misery from prejudice or outright persecution, because as individuals and as a planet we have not had the will to change these conditions.

"As I said, those thoughts and perceptions stayed with me and worked on my mind. I could see the problem; but even more importantly, I began to see a solution. It's the only possible solution but it will be enormously difficult to achieve. The solution is: *a global change of consciousness.*

"Man must rise from his present ego-centered consciousness to sense his intimate participation in the planet's functioning, and beyond that, in the functioning of the Universe. Otherwise we're doomed. It's as simple as that. It is not for the Universe to bow itself to man. It is for man, who inhabits an insignificant little planet, to find within himself, individually and collectively, ways to bring his consciousness into attunement with the Universe."

"Fear"; "prejudice"; "outright persecution" were some of the key terms in Mitchell's address. The reported facts in this book will bring into focus the rather startling conclusion that "human nature" really hasn't changed much since the Italian philosopher, Giordano Bruno, was burned alive at the stake in Rome, Feb. 17, 1600—almost four centuries ago.

During those dark ages of the Inquisition, the concept of heresy was very much in vogue. Today we are inclined to feel secure and confident in the belief that we live in an enlightened and progressive age. Or are there still fields of endeavor in the present, considered to be scientific heresies? Perhaps the conspiracy of the Inquisition has only been replaced by a less spectacular, but by no means less effective, conspiracy of silence? At times it almost seems as though the religious dogmas of the past have been superseded by the more insidious scientific dogmas of our day. There can be little doubt that research reports and experimental results seeming to run counter to accepted viewpoints can be either actively suppressed or purposely ignored whenever they tend to challenge a tenuous, hard-won equilibrium Outsiders with the audacity to announce new findings—scientific pioneers daring to question the established foundations of tenets considered sacred and infallible remain highly suspect.

"Prejudice! Outright persecution!" were some of the strong terms used in Mitchell's address. "Just living greedily . . ." was another stern warning of that modern-day Savonarola of the space-age, Capt. Edgar D. Mitchell.

Between his warnings and the following statement made to a Congressional panel in Washington, May 1974, there could indeed be a connection pertaining to the present world energy crisis. It was made by Ralph Nader, the consumer advocate, who charged that American energy companies are *actively blocking* development of new forms of energy that threaten to cut into their profits:—"The energy industry is more interested in an energy source it controls." According to the AP newspiece, he also accused large oil companies of keeping devices from being developed through a 'suppression of technological efficiency':

> "The fuel industry wants to sell oil, gas, coal and uranium. Yet with reasonable research and development programs this country could develop far more abundant, cleaner and safer energy sources," said Nader.*

Is it suppression or simply neglect by inertia? An American quip states that if there is anything more afraid of controversy than the average government-funded scientist, it is two of them.

The reader will be able to decide for himself whether technological and scientific research into new energies is being suppressed or merely neglected. In the case of talent without power, versus power without talent, the documented reports, experiments and patents listed in this book will speak for themselves.

As an essential part of the introduction of this book a short review of the course of the history of inventions and discoveries is listed below. This rather shocking review, published in an Engineering Publication in 1963, caused the author to be "called on the carpet," receiving in his personnel file the admonition: "It is restated that any journalistic activity along this line should be submitted for approval through company management."

The Content of the "Objectionable" Historical Review follows:

> "Late in the 16th century, Sir William Gilbert said, 'Science has done its utmost to prevent whatever science has done.' "

1. Only about 40 years ago, Professor Herman Oberth, the teacher of Dr. Wernher von Braun, offered his book, *By Rocket to Interplanetary Space* to about 10 different publishers. Each sent it back to him. Most had probably

Source material: AP newspiece, May 23, 1974.

never read more than the title. A one-time expert, Geheimrat Spiess, who reviewed Oberth's book, wrote, "We believe the time has not yet come for delving into such problems as these—and indeed probably never will come."

2. In his day, professor Goddard was called "Moon-mad Goddard." But last July the House passed a bill to establish March 16 as National Goddard Day. This is the anniversary of the day in 1926 when Goddard launched the first successful liquid-fueled rocket. Yet NASA's Deputy Administrator, Dr. Hugh Dryden, reported in the May, 1962 Saturday Evening Post, "One day in April last year a distinguished group of medical men called on me to argue that men still did not have the basic research needed to risk launching astronaut Alan Shepard. Manned space flight, they claimed, was just not feasible yet. When I tried to explain that we had to learn by doing, they threatened to go over NASA's head to the President! The next day, Cosmonaut Yuri Gagarin went into orbit."

3. Conservatism is always the most formidable barrier to progress, and scientific truth is no respector of recognized authorities. "It is assuredly most uncomfortable for scientists with a hard academic glaze to be confronted with an upsetting of the applecart," said Dr. George C.O. Haas, himself a scientist. To refuse to see new facts, to impede progress, to curb science, is to imitate the cartographers of old Europe, who used to write on their maps at the Pillars of Hercules (Gibraltar): "Hic deficit orbis" (Here the World Ends).

4. The forces of Conservatism, often coupled with an astonishing and profound lack of humility, are so strong that many scientists willingly believe that facts which cannot be explained by current theories do not exist. In 1830 the Royal Medical Society claimed, "The fast movement of trains causes terrific mental disturbances to the travellers as well as to the onlookers." Contemporary scientists laughed at Luigi Galvani and his electrical principles. Galileo was considered crazy by his contemporaries when he taught that the earth moves about the sun. The church pointed him out as a heretic and promptly excommunicated him.

5. Franklin was the subject of laughter at the English Academy of Science when he reported his discovery of the lightning rod. They refused to print his report. When the first telephone was on exhibition in the Academy of Science in Paris, one of the most honorable professors declared it a fake and ventriloquism!

6. Count Zeppelin, inventor of the steerable balloon, was ridiculed in 1902 on a German Engineer Day in Kiel. Paracelsus, the great physician with revolutionary ideas, was persecuted and his books were burned. Finsen, discoverer of the curative power of ultra-violet rays, was persecuted too . . . yet after his death a monument was errected in his honor.

7. The possibility of "stones falling from heaven" (meteoric iron) was vehemently denied by the great Gassendy, although a big piece of still-hot meteorite iron was brought to him. The French scientists Bertholon and Vaudin did the same, disregarding certified proof of a meteor-fall with the signatures of the mayor and 200 witnesses.

8. In the early thirties, scientists of note wrote positively that any attempt to exploit the energy contained in the nucleus would be doomed to failure because the energy derived from disintegration would be less than that required to bring about that disintegration.

9. Admiral William D. Leahy, then Chief of Staff to the President, had this to say about the atom bomb: "That is the biggest fool thing we have ever done. The bomb will never go off, and I speak as an expert in explosives." (The Truman Memoirs) A short time later, an atomic bomb vaporized a hundred thousand people.

T.H. Huxley once said, "The improver of natural knowledge absolutely refuses to acknowledge authority as such; for every great advance in natural knowledge has involved the absolute rejection of authority."

And Charles F. Kettering, the famous inventor, commented on the same subject by stating, "In research, you need a lot of intelligent ignorance. When you begin to think you know all about any subject, it stops your progress dead in that subject. It is not the things you don't know that hurt you . . . *it's the things you think you know for sure that are not so.*"

Napoleon is supposed to have said once:

"Impossible? Ce mot n'est pas francais!"
(Impossible? This word is not French!)

Well, neither is it desirable in any other language. Especially not in the language of scientific investigation!

THE AMERICAN SCENE

Taking Inventory:

TAKING INVENTORY

HOW MUCH IS ABSOLUTELY CERTAIN IN SCIENCE?

"Don't keep forever on the public road, going only where others have gone. Leave the beaten track occasionally and dive into the woods. You will be certain to find something you have never seen before"

<div align="right">Alexander Graham Bell</div>

The nuclear scientist Dr. Edward Teller has a favorite story he likes to tell: "When Columbus took off, the purpose of the exercise was to improve relations with China. Now, that problem has not been solved to this very day, but look at the by-products!"

A close reexamination of the historical growth of today's scientific dogmas or commonly accepted 'fundamental concepts' reveals likewise some surprising facts, surfacing as the by-products of such a historical review. Starting with the velocity of light, we will find for instance the following facts, revealing some glaring discrepancies in comparison to the claims of contemporary textbooks.

THE SPEED OF LIGHT

Claim:—Nothing can exceed the speed of light in vacuum, which is a *constant 186,000 miles per second* (Or *299,792 km/sec.*)

Facts:—The Danish astronomer Olaf Roemer announced the calculation of the speed of light to the Academy of Sciences in Paris in 1676. He had calculated the velocity as *227,000 km/sec.* or *141,000 miles per second.* In 1926, Prof. A.A. Michelson flashed light between mirrors on mountain peaks 22 miles apart and clocked the speed at *182,284 miles per second.* To ob

21

a more accurate figure, he directed the construction of a tube a mile long at Pasadena, California so that the speed of light could be measured in a vacuum. After his death in May 1931, the task was carried on by two other scientists. In 1932, the light measurements showed such marked discrepancies with previous results as to occasion a distress call to the U.S. Coast & Geodetic Survey, whose surveyors repeatedly remeasured the length of the tube and found no error. Variations of 12 miles per second and more were recorded. The speed *seems to vary with the season* and also in a shorter cycle lasting about two weeks.* Finally, the scientists ended by taking an average of all the readings, which was announced in 1934 as *186,271 miles per second.*

The Special Theory of Relativity began by *assuming* the velocity of light in a vacuum to be a fundamental and unvarying constant. (Einstein in 1905) The same theory postulates that the velocity of light is the *ultimate* speed limit. At that speed, mass would become infinite.

Not so, claims Dr. J.H. Sutton of NASA, who is concerned with finding clues toward a better understanding of gravity. Einstein's equations only make it impossible to find enough energy to accelerate a particle of finite mass to a speed greater than that of light. A particle "born" with a speed in excess of c (speed of light) is not prevented by relativity from continuing on its way!

The discovery of new particles in nuclear physics challenges Einstein's theories. In 1967, Prof. Gerald Feinberg, a theoretical physicist at Columbia University, New York, published his new theory concerning *tachyons*, a word derived from the Greek "Tachyos" = fast. Feinberg supplied mathematical proof that these particles move infinitely fast, but become slower as they approach the speed of light. (Published in PHYSICAL REVIEW, 1967).

On August 28, 1970, two British scientists, John Allen and Geoffrey Endean announced their discovery of an E/M field in which particles move at a speed of about *twice* that of light. According to these scientists, the characteristics of this particular E/M field alone "would prove erroneous Einstein's theory."

In 1974, Dr. Marcel Pages, doctor of nuclear engineering and medicine in France; a founder-member of C.I.R.G., an international research center for gravitation; created in Rome, Italy, in 1961, published his important book, "Le Defi de L'anti-gravitation" (The Challenge of Antigravitation) which states calculated fields with speeds superior to the speed of light are possible. Some of Dr. Pages' scientific articles in "Revue Francaise D'Astronautique" have been translated by the NASA translation service for the benefit of NASA researchers.

*"Mystery of Variation in Speed of Light," in *Popular Science Monthly*, March 1934, p. 25 (USA)

The Gravitational Constant

Claim:—The acceleration of gravity, G, *is constant,* at any location. For instance the weight of one kg. near the surface of the earth where the acceleration of gravity is 9.8 m/sec. every second, is 9.8 Newtons.

Remark:—If the *gravitational constant* holds true, then the weight of an object is proportional to its mass. However, while weight and mass are proportional to one another, it should be noted that they are *different entities.* Weight is the vertical force of gravity, mass is an inertial property. The mass of an object referred to in the law of gravitation is called gravitational mass, in contrast to inertial mass. Einstein used the *seeming* equality of the inertial and gravitational mass as a basis for the general theory of relativity.

Facts:— Dr. Erwin J. Saxl, a one-time student of Albert Einstein, proved in his experiments that the *assumption* of gravitational constant is incorrect and obsolete (See Sec. No. 5: "The Gravitational Constant is not constant at all"). Dr. Saxl was able to verify that gravity and electricity do in fact interact under dynamic conditions. In 1968, Dr. Saxl's claims were unexpectedly confirmed from another corner of the world by a dissertation from the Karl Marx University in Leipzig. Titled (translated) "About the influence of electrostatic fields on the periods of gravitational pendulae," this thesis by one Harald Fischer from Taucha DDR, (German Democratic Republic) is available at the university library in Mainz, West Germany.

Like a chain reaction, the fundamental definition for *inertia* enters the changing picture when we hear about the late French Nobel Prize winner in physics, Gabriel Lippmann (1908) and his assertion that an ordinary atom in the normal state has inertia only because it has certain electrical properties, more precisely a net positive charge effect; small as it may be. He too demonstrated the validity of the principle when he found that bodies in the charged state offered a greater resistance to acceleration than when they were uncharged, thus altering the inertial properties of these bodies. His experiments were quickly and conveniently "forgotten" since they undermined the established scientific "laws" involving mass and inertia.

Prof. Hermann Oberth, the teacher of space scientist Dr. Wernher von Braun, stated in a private letter of Nov. 5, 1970 to this author: "I am inclined to believe, more and more, that inertia, gravity and energy represent merely different sides of one and the same thing. Similar to the fact that one cannot very well dissect my person and then claim:

This is the Professor,
this is the Hermann, and
this is the Oberth."

Returning again to Dr. Saxl's work, this short excursion into strange territory could be concluded by repeating that the *gravitational constant* can apparently be altered and modified by electrical forces. Or to put it more bluntly: it appears now certain that the *force of gravity* can be altered, influenced and even reversed by electrical forces. This bold assertion may serve as the icebreaker and introduction for the experiments reported in the following chapter.

A DRAMATIC REPORT

There is a strange report on the shelves of an American Technical library, the *Pacific Aeronautical Library* in Los Angeles, 7660 Beverly Boulevard.

Datelined April 8, 1952, its author is listed as *Mason Rose, Ph.D.*, formerly President of the now defunct "University for Social Research" in California.

Surprisingly, it is not classified as CONFIDENTIAL or SECRET, although its implications can only be compared to those of a rough, uncut diamond in value.

Illustrated with simple, freehand sketches, this so-called "nomograph for human technoloy" portrays the findings of Professor Biefeld of Denison University and T. Townsend Brown, his protégé, concerning the coupling effects between electricity and gravitation.

A summary of the report follows:

THE FLYING SAUCER

A Simplified Explanation of the Application of the Biefeld-Brown Effect to the Solution of the Problem of Space Navigation.*

by
Mason Rose, Ph.D., President
University for Social Research

The scientist and layman both encounter a primary difficulty in understanding the Biefeld-Brown effect and its relation to the solution of the flying saucer mystery.

*A copy of the original report is in the possession of the author.

This difficulty lies in the fact that scientist and layman alike think in electromagnetic concepts, whereas the Biefeld-Brown effect relates to *electrogravitation.*

Neither scientist nor layman can be expected to know the details of electrogravitation, in as much as it is a comparatively recent and unpublished development. Townsend Brown is the only known experimental scientist in this new area of scientific development. Thus anyone who wishes to understand electrogravitation and its application to astronautics must be prepared to lay aside the commonly known principles of electromagnetics in order to grasp the essentially different principles of electrogravitation. Electrogravitation must be understood as an entirely new field of scientific endeavor and technical development, which does not obey the known principles of electromagnetism.

Perhaps the best way to gain an understanding of electrogravitation is to review the evolutionary development of electromagnetism.

From the smallest atom to the largest galaxy, the Universe operates on three basic forces—namely, electricity, magnetism, and gravitation. These three forces can be represented as follows:

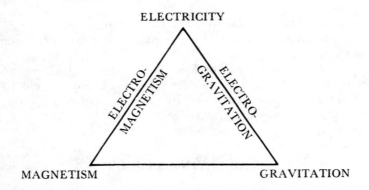

Taken separately, neither is of much practical use. Electricity by itself is static electricity, and therefore functionless. It will make your hair stand on end, but that is about all.

Magnetism by itself has few practical applications aside from the magnetic compass, whereas gravity simply keeps objects and people pinned to the earth.

However, when these are coupled to work in combination with each other, almost endless technical applications arise. To date, our total electrical development is based on the coupling of electricity with magnetism, which provides the basis for the countless uses we make of electricity in modern societies.

Faraday conducted the first productive empirical experiments with electromagnetism around 1830, and Maxwell did the basic theoretical work in 1865.

The application of electromagnetism to microscopic and submicroscopic particles was accomplished by Max Planck's work in quantum physics about 1890; then in 1905 Einstein came forward with Relativity, which dealt with gravitation as applied to celestial bodies and universal mechanics.

It is principally out of the work of these four great scientists that our electrical developments ranging from the simple light bulb to the complexities of nuclear physics have emerged.

Then, in 1923, Professor Biefeld of Denison University suggested to his protégé, Townsend Brown, certain experiments which led to the discovery of the Biefeld-Brown Effect, and, ultimately, to the electrogravitational energy spectrum.

After twenty-eight years of investigation by Brown, it appeared that for each electromagnetic phenomenon there exists an electrogravitational analogue.

From the technical and commercial viewpoint, this means that the potential for future development is as great or greater than that of the entire present electrical industry!

Consider only that electromagnetism is basic to telephone, telegraph, radio, television, radar, electric generators, motors, and power production and transmission. Secondarily, it is indispensible to transportation of all kinds.

One does not then have to stretch the imagination far to foresee a parallel development in the electrogravitational field!

The first empirical experiments by Townsend Brown had the characteristic simplicity which has marked most other great scientific advancements, and concerned the behavior of a condenser when charged with electricity.

The startling revelation was that, if placed in free suspension with the poles horizontal, the condenser, when charged, exhibited a forward thrust toward the positive pole! A reversal of polarity caused a reversal of the direction of thrust.

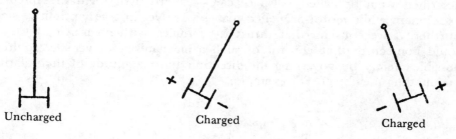

Uncharged Charged Charged

Further development of the implications of this phenomenon illustrated an "antigravity" effect. When balanced on a beam balance, and then charged, the condenser moves. If the positive pole is up, the condenser moves *up* (i.e., becomes "lighter"); if the positive pole is pointed down, it moves *down* (becomes "heavier").

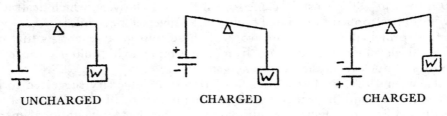

UNCHARGED CHARGED CHARGED

These two simple experiments demonstrate what is now known as the Biefeld-Brown effect. To the best of our knowledge, it is the first method known of affecting a gravitational field by electrical means, and may contain the seeds of the control of gravity by Mankind.

The intensity of the effect is determined by five factors.

1. The separation of the plates of the condenser—closer plates, greater effect.
2. The higher the "K" factor, the greater the effect. ("K" is a measure of the ability of a material to store electric energy in the form of elastic stress.)
3. The greater the area of the condenser plates, the greater the effect.
4. The greater the voltage (potential) difference between the plates, the greater the effect.
5. The greater the mass of the material between the plates (dielectric), the greater the effect.

It is this last point which is inexplicable from the electromagnetic viewpoint, and which provides the connection with gravitation.

On the basis of further experimental work, in 1926 Townsend Brown described what he called a "space car"—a method of flight presented for experiment while motor-propelled planes were yet in a very primitive stage. Further, if we consider that thrust is produced with no moving parts, we could conjecture that control of such a mechanism, or vehicle, could be possible merely by governing the direction and magnitude of the polarities surrounding the object. For example:

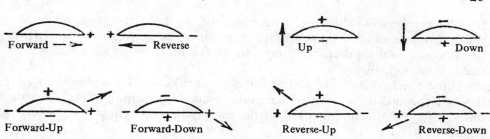

Knowing that the "saucer" always moves toward its positive pole, control is accomplished simply by varying the orientation of the positive charge. That is, by switching charges, rather than by dynamic control surfaces. The direction of movement would be a vector sum (added average) of the direction and amount of negative and positive charges acting on such a body.

By experiment, Brown had developed an electrostatic propulsion method which was proven on a scale model going around a stationary pole (Pat. No. 2,949,550). There seemed to be no limit to the speed possible, when run in a vacuum, and the machine had to be shut off before it developed enough inertia to fly apart under those conditions.

Further, the evolutionary development dictated that the plan view most appropriate for the best results was circular—being developed along the lines shown below. (Lines left of the figure indicates the positive electrode, the "disc" itself being electrically negative.)

After working with the problem of horizontal thrust, Brown developed a profile shape which would be most efficient to shape the resulting electrogravitational field for maximum lift. The final profile was approximately the shape shown here.

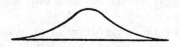

There are two other problems inherent in the attempt to produce a viable flying machine by these basic principles; one is the problem of directional control—the other, the question of stability, of which more will be said in a later chapter.

Directional control (as well as forward speed) could be achieved, in part, through the use of segmented structure, whereby a turning effect, or rotational effect, could be imparted to the mechanism by switching in different segments.

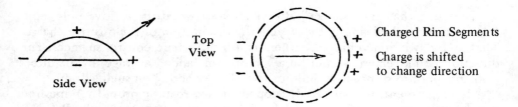

Note that the upper plate is charged positive, the lower, negative, for lift: Resultant direction between thrust and lift is indicated by arrows.

With these basic operations in mind, let us recall that the first recorded report of a disc-shaped object in the sky dates back to the Sixteenth Century (excluding Biblical references in the Book of Ezekiel, and folklore.)

At long intervals in the interim, other reports enter the stream; most of them probably distorted by telling and retelling. In the older reports, as well as in the numerous series which has accumulated since 1947, there is a tantalizing common thread concerning appearance and behavior which makes any certainty about the "unreality" of flying saucers most debatable.

1. There is, in most cases, no method of propulsion which can readily be understood. No propellors. On occasion, a long flame jet trailing behind a cigar-shaped object, which is usually orange-red in color (indicating an inefficient combustion), which in turn would make it ineffective as a reaction jet such as we know in rockets and jet planes.

2. Descriptions show a range of speeds from stationary hovering to speeds greater than present-day rockets can deliver. Changes in rate of motion, direction, and the resultant stresses seem beyond the capabilities of any vehicles we know of today, operating within our currently-accepted framework of Newtonian physics. The accelerations, within this system of thought, would impose impossible stresses on any occupants.

3. Reports of night sightings describe a glow, usually blue or violet color, around the periphery of the object. Physicists have noted that

such a glow is one characteristic of a very high voltage electrical discharge.

4. Description of shapes and performance seems to indicate a complete disregard of currently understood aerodynamic principles. The objects seem to be independent of the fluid (air—in some cases, water) thru which they move. They seem to need no specially formed surfaces to interact dynamically with the fluid to generate pressure differences, and thus, "lift."

Let us now review these observations in the light of what we know of the Biefeld-Brown Effect.

1. No understood method of propulsion.

—The "Saucers"made by Brown have no moving parts at all. They create a modification of the gravitational-electrical field about themselves, which is somewhat analogous to putting them on the incline of a hill. They act as a surfboard on a wave; the electrostatic activity apparently creating a local distortion of the gravitational field, down which the vehicle "slides."

2. Tremendous accelerations and changes of direction.

—According to current thinking and technology, both machine and occupants would endure unbearable stresses. "Not so," says Brown. No stresses would be felt, since craft, occupants, and load respond equally to the wave-like distortion of the local gravitational field as a unit.

In a plane, the propellor pumps air backward, and *by reaction* moves itself forward. The reaction against the propellor is transferred to the frame of the aircraft, which then *shoves* occupants and load forward, contrary to their natural tendency to move at a constant rate in a constant direction.

In the saucer, the entire assembly moves in unison in response to the locally modified gravitational field. (Our nearest analogy would be in going *down* in an elevator. When the elevator starts down, both elevator and its occupants share a gravitational tendency to move down, and they do so without any shoving or stresses between elevator and passengers. If acceleration is controlled smoothly enough, there is barely any perceptible sensation of movement.)

3. Brown's discs require a highly-charged leading edge, the positive pole. Such a charged edge produces a visible corona. On the largest models made, this develops a decided bluish-violet glow, easily visible in darkness or dim light. A full-scale ship would be expected to produce a spectacular corona effect, visible for miles.

4. Independence of aerodynamic effects.

—The ionized air generated by the positive pole ahead of the disc

Thomas Townsend Brown

would tend to create a partial vacuum—sort of a "buffer zone" permitting movement of the air out of the way of the moving object (which we conjecture is being driven by an altered electrostatic field interacting with earth's gravitational field in some way.) It *needs no air for lift.*

5. Finally, when Brown turned his attention to improved ways of generating high voltages, the most promising new method was the use of a flame jet to convey negative charges astern! This flame was relatively inefficient as a generator when it was adjusted for the best combustion of the fuel; *but* if it was adjusted to orange-red, indicating incomplete combustion of the fuel, it conveyed the charges very efficiently, and set up the required negative space charge behind the craft!

We here refer the interested reader to Professor Dudley's experiments with rockets (Pat. No. 3,095,167) and its application to points four and five above. It should be noted that in a jet plane or guided missile the extra weight added to create the Biefeld-Brown electrogravitational effect, (or, in the methods of Dr. Dudley), would be well compensated for by the additional thrust created by the movement of the vehicle toward the positive field created in front of it. Dudley's rockets achieved heights of up to *six* times the normal, utilizing the same propulsive charge.

A short summary of T. Townsend Brown

While questioning the basis of the above report, the existence of Denison University can quickly be established; and it is equally possible to verify a former faculty member as a Professor Paul Biefeld.

A careful survey, following Dr. Rose's report, revealed that Denison University in Granville, Ohio, was founded in 1831 as a religious institute of learning. The library of the university verified that a Prof. Paul Alfred Biefeld did serve as a member of the faculty there. The 1944 edition of *American Men of Science* states that (page 45) Prof. Paul A. Biefeld was born in Konigswalde, Germany, March 22, 1867; received his Ph.D. in Zurich, 1900, and became assistant to Prof. H.F. Weber in Switzerland. From 1900 to 1906 he served as professor of physics, mathematics, and electrical engineering at the Technical School in Hildburghausen, Germany, and from 1911 to 1936 as professor of Astronomy and Director of Swasey Observatory, Denison, Ohio. His specialties are listed as physics and electrical engineering.

The U.S. Patent Office in Washington confirms the granting of 6 different patents to a Mr. Thomas Townsend Brown: the first, issued on September 25, 1934, for an electrostatic motor. The last, under Patent No. 3,187,206,

June 1, 1965, for an electrokinetic apparatus. The patent contents in turn confirm the basic legitimacy of the claims made in Dr. Rose's report of Section 1.

It is a rather disconcerting commentary that the vast majority of aerospace engineers and scientists have never heard of Brown's work; nor, apparently, have the fortunate few who have, grasped its significance.

(A 1956 article in a well-known international magazine for aviation and astronautics published in three languages a summary of Brown's finding under the title "Towards Flight Without Stress or Strain—or Weight.")

We find that Thomas Townsend Brown was born in 1905, the son of a rather well-to-do family in Eastern Ohio.

One of the mysterious discoveries of that period was the "X-ray"; and apparently Thomas had wondered whether this could possibly be a key to space travel.

He purchased a Coolidge X-ray tube to begin his experiments, since this mysterious machine of Wilhelm Konrad Roentgen was far more fascinating to the youth of that time than it is today. After all, didn't X-rays permit photography through walls, and even through the human body?

Thomas carefully mounted his X-ray tube in a balance, like a telescope; and by pointing it in different directions, he somehow hoped to find a variation in the power of the tube or in the strength of the X-rays it generated. A wild idea, perhaps, but curiosity must be satisfied!

However, no matter how he oriented his tube, there appeared to be no difference in power output—no variation in the strength of the X-rays.

BUT—and here is where the genius for careful observation comes in—he did notice something rather unexpected. The Coolidge-tube generated a type of thrust, as if *it* wanted to move! He soon learned that this tendency to move was not produced by the X-rays as such, but was a "by-product" of the high voltage, which the tube required. He made certain that the force was not one of the already known effects of high voltage, finding instead that it acted like a *mass* force—like gravity!

Extending his investigations, Brown designed and fabricated an apparatus called a "gravitor." This was essentially a multiple capacitor—and perhaps indeed an optimistic designation. But when the apparatus was put on a scale and connected to fifty thousand volts D.C., the scale indicated either a gain or a loss of *one percent of weight!* This gain or loss depended *only* on whether the "Gravitor" was oriented with the *positive* or the *negative* side upwards.

Though local newspapers reported this experiment, no scientist expressed the slightest interest.

Badly disappointed, Brown decided to enroll in a University as a Freshman, in order to gain the prerequisites for recognition of his discovery. His

first school year showed him to be an excellent laboratory man and mathe-
matician.

At the end of the year he set up the "Gravitor" in his quarters, inviting
all faculty members who could reasonably be expected to have some interest
in his discovery to witness a demonstration of the electro-gravitational force.

Not a single member showed up!

Brown, deeply hurt by what he felt to be high-handed treatment, quit
school and joined the Navy. Completing his technical education, he wrote his
first paper in August of 1929, describing his discovery in *Science and Inven-
tion* as "How I Control Gravitation." A subtitle explained how the article
dealt with the meaning of "Field Theories" and the relationships between
electro-dynamics and gravitation. Experimental confirmation and practical
results were given:

"Dr. Einstein's announcement of his recent work has spirited the physi-
cists of the entire world to locate and demonstrate—if possible—any struc-
tural relationship between electro-dynamics and gravitation The writer
(Brown) and his colleagues anticipated the situation as early as 1923, and
began to construct the necessary theoretical bridge between the two then
separate phenomena—electricity and gravitation.

"Since the first tests, the apparatus and methods used have been greatly
improved and simplified. Molecular gravitors made of solid blocks of massive
dielectric have given greater efficiency. Rotors and pendulums operating
under oil have minimized atmospheric considerations of pressure, tempera-
ture, and humidity. Disturbing effects of ionization, electron emission, and
pure electro-statics have likewise been carefully analyzed and eliminated.
After years of refinement in methods, we succeeded in observing the gravita-
tional variations produced by the moon and sun, and the much smaller
variations produced by the different planets. *It is a curious fact that the
effects are most pronounced when the affecting body is in the alignment of
the differently charged elements, and least pronounced when it is at right
angles!*"

"Much of the credit for this research is due Dr. Paul Alfred Biefeld,
Director of Swasey Observatory. The writer (Brown) is deeply indebted to
him for his assistance and for many valuable and timely suggestions."

Brown concluded his paper,

"The Gravitor, in all reality, is a very efficient motor. Unlike other forms
of motors it does not in any way involve the principles of electromagnetism,
but instead it utilizes the principles of *electro-gravitation*. A simple gravitor
has no moving parts, but is apparently capable of *moving itself from within
itself*. It is highly efficient for the reason that it uses no gears, shafts, propel-
lors, or wheels in creating its motive power. It has no internal mechanical
resistance and no observable rise in temperature. Contrary to the common

belief that gravitational motors must necessarily be vertical acting, the gravitor, it is found, *acts equally well in every conceivable direction.*

"While the gravitor is at present primarily a scientific instrument—perhaps even an astronomical instrument—it also is rapidly advancing to a position of commercial value . . . multi-purpose gravitors weighing hundreds of tons may propel the ocean liners of the future. Smaller and more concentrated units may propel automobiles and even airplanes. Perhaps even the fantastic 'space cars' and the promised visit to Mars may be the final outcome. Who can tell?"

The reader will bear in mind that when this paper was published in 1929, the term "UFO" and the observed E/M effects of these mechanisms were both completely unknown!

By mid-WW II, Mr. Brown's scientific ability and reputation as a brilliant engineer had catapulted him to the rank of Lieutenant Commander, and Commanding Officer of the U.S. Navy Radar School at Norfolk, Virginia. Working too many hours, he finally collapsed. Retiring from the Navy, he was able to recuperate after a period of six months, and accepted a position with Lockheed-Vega.

In the ensuing years, he never again, on his own initiative, attempted to interest anyone in his discovery of electro-gravitation. When questioned by his colleagues concerning his experiments, he would refer to them only in terms of "stress in dielectrics"—a pertinent paraphrase, but one sounding much less sensational.

After the war, a group of Navy students at Pearl Harbor, Hawaii, repeated the experiments under the guidance of an engineer friend of Brown's. In the presence of U.S. Admiral Radford, the experiment succeeded, and Brown was congratulated for his discovery. Though his colleagues were immensely proud of him, despite the fact that the lifting force was still quite small, no one in the academic world seemed to evidence any interest.

Not easily discouraged either, his friends arranged demonstrations to the business world and for governmental officials. The experiments were noted to be "interesting," but considered "of little commercial value." The support his friends had hoped for did not materialize. Even the late Dr. Robert Millikan, invited to attend a demonstration of influencing gravitational forces, was reported to have said, "Such a thing is impossible and out of the question."

Brown's friends eventually concluded that scientists in America were intellectually inert, and arranged to have Brown go to Europe in hopes of finding more perceptive interest there.

In England and France, he received encouraging commentaries and was written up in Air and Space magazines; however, the expected recognition

for his breakthrough did not materialize.

Meanwhile, a small corporation was organized to carry out further work without depending on federal financial support.

Applications for over 75 patents in 12 major countries were initiated.

Lift, or gravitational force, was slowly increased until one particular type of apparatus was capable of lifting itself directly when voltage was applied.

At about this time, T.T. Brown seems to have made "the mistake of his life." He showed an interest in the newly-reported phenomenon of "Unidentified Flying Objects," and founded the Organization NICAP in Washington, D.C., September, 1956.

The doors of America's scientific press clanged shut, and the "Conspiracy of Silence" took precedence, before all else!

COMMENTARY ON T.T. BROWN'S WORK

In the spring of 1956, the internationally known aviation magazine *IN-TERAVIA* in Genf, Switzerland, published a sensational article, "Towards Flight Without Stress or Strain . . . or Weight," which carried the editiorial remark: "The following article is by an American journalist who has long taken a keen interest in questions of theoretical physics and has been recommended to the Editors as having close connections with scientific circles in the United States. The subject is one of immediate interest and INTERAVIA would welcome further comment from initiated sources."

On the first page of this particular article, a photo is displayed with the caption, "The American scientist, Townsend T. Brown has been working on the problems of electro-gravitics for more than thirty years. He is seen here demonstrating one of his laboratory instruments, a disc-shaped variant of the two-plate condenser."

The article states, "Electro-gravitics research, seeking the source of gravity and its control, has reached a stage where profound implications for the entire human race begin to emerge. Perhaps the most startling and immediate implication of all involved aircraft, guided missiles, atmospheric and free space flight of all kinds . . . and towards the long-term progress of mankind and man's civilization, a whole new concept of electro-physics is being levered out into the light of human knowledge."

Commenting on technical details of the work involved, it continues: "A localized gravitic field used as a ponderomotive force has been created in the laboratory. Disc airfoils two feet in diameter and incorporating a variation of the simple two-plate condenser charged to fifty kilovolts and a total continuous energy input of fifty watts have achieved a speed of seventeen feet per second in a circular course twenty feet in diameter More recently, these discs have been increased in diameter to three feet and run in a fifty-foot

diameter air course under a charge of 150 kilovolts, with results so impressive as to be highly classified. Variations of this work done under a vacuum have produced much greater efficiencies that can only be described as startling. Work is now under way developing a flame-jet generator to supply power up to fifteen million volts."

"The most successful line of the electrogravitics research so far reported is that carried on by Townsend T. Brown, an American who has been researching gravity for over thirty years. He is now conducting research projects in the U.S. and on the Continent. He postulates that there is between electricity and gravity a relationship parallel and/or similar to that which exists between electricity and magnetism. And as the *coil* is the usable link in the case of electromagnetics, so is the condenser that link in the case of electro-gravitics. Years of successful empirical work have lent a great deal of credance to this hypothesis. The detailed implications of man's conquest of gravity are innumerable. In road cars, trains and boats, the headaches of transmission of power from the engine to the wheels or propellers would simply cease to exist. Construction of bridges and big buildings would be greatly simplified by temporarily induced weightlessness, etc."

The author finally concludes with the carefully phrased remark, "Of course, there is always a possibility that the unexplained 3% of UFO's,—'Unidentified Flying Objects' as the U.S. Air Force calls flying saucers,—are in fact vehicles so propelled, developed already and undergoing proving tests . . . but by whom, the U.S., Britain, or Russia? However, if this is so, it is the best-kept secret since the Manhattan Project, for this reporter has spent over two years trying to chase down work on gravitics, and has drawn from Government scientists and military experts the world over only the most blank of stares. This is always the way of exploration into the unknown."

———————

A mere month or two later, a Frenchman named Lucien A.A. Gerardin, Head of the Nuclear Physics Section, Compagnie Francaise Thomson-Houston, in Le Raincy, France, published a follow-up to the Interavia article, entitled ELECTRO-GRAVITIC PROPULSION. As to the theoretical part of the problem, he says,—"For propulsion to be ideal a balance would have to be created on the atomic level. This is a new approach to the problem which has virtually no point of contact with the present solution. It would no longer be a matter of generating a force localized at one point, but a field of inertial forces roughly uniform in the whole of the region around the vehicle. With weight thus being balanced on the atom level, there would no longer be any limitation on the accelerations possible. As this field of forces is no longer strictly localized, the air adjacent to the vehicle will also be carried along. The heat barrier, ultimate limiting factor to the speed of present aircraft, will disappear. Actually, however, the field will decrea

distance from the generator increases. Thus only part of the air will be carried along; nevertheless the maximum speed obtainable will be very high."

Proceeding then to considerations of nuclear physics, he continues,— "Though electrically neutral in the mean, matter is built up of enormous quantities of negative electricity (electrons) and positive electricity (protons). An attempt may be made to explain gravitational attraction as due to a *very small residue* of interaction between electricized particles. Such an attempt at explanation must be guided by the specific characteristics of gravitation. Gravitation may then be connected with kinetic electromagnetic quantities, for example, the multi-polar moments in the nuclei. It is thus clear that knowledge of the nature of gravitational forces is closely connected with the nature of the atomic nucleus."

"As Frederick J. Belinfante wrote in 1955, 'The discovery of many types of strange particles during recent years has drawn new attention to the fact that we really don't understand why those particles exist with the properties we observe'."

"Why, for instance, is a proton 1,836 times heavier than an electron? Why is there no neutral mu-meson of mass 200? Why is hc/e^2 equal to 137? An ultimate theory of matter should explain such things."

Further considerations in the article by Monsieur Gerardin seem to be of interest principally to the scientifically trained reader. In concluding his paper, he is attempting to make a point: "In 1955 Anselm E. Talbert wrote in the New York Herald Tribune that up to now no scientist or engineer, so far as is known in scientific circles, has produced the slightest alteration in the magnitude or direction of gravitational force although many cranks and crackpots have claimed to be able to do this." But this certainly does not mean that the thing is impossible and that our century will not see vehicles with electro-gravitational propulsion. After all, it took only some ten years to reach industrial mastery of Atomic Energy.

When referring to electro-gravitational propulsion (a problem which his company was the first to tackle in the United States) George S. Trimble, Vice-President of the Glenn L. Martin Company said, "I think we could do the job in about the time that is actually required to build the first atomic bomb if enough trained scientific brain-power simultaneously began thinking about and working towards a solution. Actually the biggest deterrant to scientific progress is a refusal of some people, including scientists, to believe that things which seem amazing can really happen."

In connection with T.T. Brown's visit to Europe, the Journal of the British Interplanetary Society was daring enough to print a detailed commentary written by Mr. A.V. Cleaver, Assistant Chief Engineer of the Aero Engine Division of world-famous Rolls-Royce, Ltd. Headlined "ELECTRO-

GRAVITICS, WHAT IT IS OR MIGHT BE." the article started as follows, "During the past two years, there can be few people in any way interested in either aeronautics or astronautics who have not encountered the unfamiliar term 'electro-gravitics' and reacted to it with perplexity, amusement, skepticism, or perhaps a mixture of all three of these attitudes."

"What are the facts," inquires Mr. Cleaver, "insofar as they are publicly known, or (as of this date) knowable?" "Well, they seem to amount to this; the Americans have decided to look into the old science-fictional dream of gravity control or anti-gravity—to investigate, both theoretically and (if possible) practically, the fundamental nature of gravitational fields and their relationship to electro-magnetic and other phenomena. And someone (unknown to the present writer) has apparently decided to call all this study by the high-sounding name of 'electro-gravitics' . . . However, that the effort is in progress there can be little doubt. And, of course, it is entirely to be welcomed. On the other hand, our own Arthur C. Clarke tells me that he recently discussed the matter with a well-known American science journalist in New York and was assured that the whole business was a case of 'much ado about nothing' started by 'a bunch of engineers who don't know enough physics.'

"It is much more probable that the work is, by modern standards, proceeding on a quite modest and exploratory scale, and that we simply have to wait and see how it will turn out. We can at least hope that, if the effort persists, the physicists in the long run may provide the essential new and basic knowledge for the 'ignorant' engineers to use. At any rate, there is one conclusion which can, even at this juncture, be stated with certainty. If any anti-gravity device is ever to be developed, the first thing needed is a new discovery in fundamental physics—a NEW PRINCIPLE—not a new invention or application of known principles, is required. New knowledge of the sort required might come from theoretical researchers in the more abstruse realms of mathematical physics, or from a more or less accidental experimental observation. Both these avenues have, in the past, led to fundamental scientific discoveries."

Proceeding next to the problematical nature of gravity, Cleaver has this to say,—"Gravity is, in fact, a most mysterious and intractable phenomenon. It is perhaps doubtful whether many people, even technically-trained people, realize just how true this is or whether they notice the conspiracy of silence with which it is treated in most textbooks. One is almost reminded of a Polynesian 'taboo' or the Victorian attitude to certain things, like sex or certain parts and functions of the body, considered 'not quite nice.' The student is taught that all masses attract one another according to the law $F = \frac{G \times M_1 \times M_2}{d^2}$ He learns that it governs the stability of the Universe and the various Newtonian equations which describe its effect, such as $H = \frac{1}{2} \times g \times t^2$.

However, unless he is a very specialized post-graduate student in pure science, he is likely not to be expected to accept the old idea of 'action at a distance'; and it is rather improbable that any of his teachers will draw his attention to our complete lack of knowledge of the physical relationship between gravitation and other phenomena, simply because we *do know nothing,* and the academic world apparently prefers not to advertise the fact!"

"A great modern physicist, Max Born, once wrote, 'perhaps when we had a more complete knowledge of the interaction of forces in the atomic nucleus we should find that gravitation was the result of something left over, a sort of incomplete compensation.'

"Having made the statement that 'in the past, a familiar pattern has been that new scientific advances have been pioneered over here, or on the Continent, and then exploited by our friends across the Atlantic. The basic science has been mainly European, even when the technology has become predominantly American, at least in its later stages'," Mr. Cleaver concluded his article with the comment, "If native Americans produce anti-gravity, by any method, then the achievement will also be notable for being one of the first major scientific discoveries or inventions to their credit. This is not meant in any derogatory sense, for the Americans might well rest content with their great reputation for the subsequent development and application on a vast scale of the ideas of others. Nevertheless, it remains a historical fact (possibly a historical accident) that more original thought has tended, in the past, to emanate from Europe, together (let us admit) with a lot of short-sightedness about its application."

"Let us conclude then, by wishing our American cousins the greatest of good fortune with 'electro-gravitics.' If they succeed in producing an anti-gravity device, they will have revolutionized a good deal more than astronautics. Aeronautics, too, fairly obviously; but consider also the effects on the design and construction of buildings and other structures, the effect on the use of cranes, lifts, escalators, stairways; in fact, each and every kind of lifting device known to man. And the rocket, after all the work and hopes lavished upon it for a couple of generations, might go the astronautical way of the dirigible in aeronautics-a vehicle which never fulfilled its promise."

––––––––––––

To render the foregoing more intelligible, the reader might well consider the following summary: Since all matter consist of atoms and each and every atom possesses an electro-positive nucleus (protons) surrounded by electro-negative electrons, a typical atom is always in an electrically neutral field. However, if the atom is placed within the electrical field of a capacitor, its *atomic field* will become distorted, the nucleus being pulled in towards the negative plate, and the electron-field being pulled in the opposite direction,

towards the positive plate. Thus the normally symmetrical field of the atom becomes *asymmetrical* when placed in an electrical field and acquires the properties of a *dipole* with a *polarity opposite that* of the inducing field. It is for this reason that Townsend T. Brown preferred to call what is now known as the "Biefeld-Brown Effect" by the name "stress in dielectric material."

Thus, according to Monsieur Lucien A.A. Gerardin again, gravitation might therefore possibly become a function of "kinetic electromagnetic phenomena within the atomic nuclei."

References:—1. *INTERAVIA,* Vol. XI, No. 12, 1956, pp. 992 (Switzerland)
 2. *JOURNAL OF THE BRITISH INTERPLANETARY SOCIETY,* Vol. 16, 1957 pp. 84-94

ADDENDUM

Electron Cloud Displacement of Charge

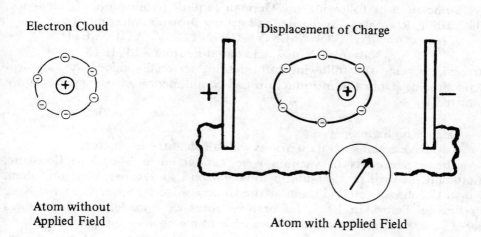

Atom without
Applied Field

Atom with Applied Field

ELECTROFLUIDMECHANICS: "A Study of Electrokinetic Actions in Fluids'" by Henry R. Velkoff.
 (Technical Report No. ASD TR 61-642)—not classified—Feb. 1962 p. 18
 Propulsion Laboratory, Aeronautical Systems Division
 Air Force Systems Command
 Wright-Patterson Air Force Base, Ohio

"ELECTRIC WIND" IN A HARD VACUUM?

Some months following the German "Pilot" publication of this work, the author, Rho Sigma, succeeded in locating Brown's whereabouts.
A letter from THE TOWNSEND BROWN FOUNDATION, LTD.
 Nassau, Bahamas, and dated February 14, 1973
arrived, carrying the following information, personally signed by T. Townsend Brown. (Only the introduction and complimentary closing passages are omitted.)

Dear (Rho Sigma),
You have asked several questions which I shall try to answer.
The experiments in vacuum were conducted at Soc. Nat. Construc, Aeronaut, in Paris in 1955-56, in the Bahnson Laboratories, Winston-Salem, North Carolina in 1957-58 and at the General Electric Space Center at King of Prussia, Penna. in 1959. Laboratory notes were made, but these notes *were never published* and are not available to me now.

The results were varied, depending upon the purpose of the experiment. We were aware that the thrust on the electrode structures were caused largely by ambient ion momentum transfer when the experiments were conducted in air. Many of the tests, therefore, were directed to the exploration of this component of the total thrust.

In the case of the G.E. test, cesium ions were seeded into the environment and the additional thrust due to the seeding was observed. In the Paris test miniature saucer type airfoils were operated in a vacuum exceeding 10^{-6} mm Hg.

Bursts of thrust (towards the positive) were observed every time there was a vacuum spark within the large bell jar. These vacuum sparks represented momentary ionization, principally of the metal ions in the electrode material. The DC potential used ranged from 70 KV to 220 KV.

44

Condensers of various types, air dielectric and barium titanate were assembled on a rotary support to eliminate the electrostatic effect of chamber walls and observations were made of the rate of rotation.

Intense acceleration was always observed during the vacuum spark (which, incidentally, illuminated the entire interior of the vacuum chamber.) Barium Titanate dielectric always exceeded air dielectric in total thrust. The results which were most significant from the standpoint of the Biefeld-Brown effect was that thrust continued, *even when there was no vacuum spark*, causing the rotor to accelerate in the negative to positive direction to the point where voltage had to be reduced or the experiment discontinued because of the danger that the rotor would fly apart.

In short, it appears there is strong evidence that the Biefeld-Brown effect does exist in the negative to positive direction in a vacuum of at least 10^{-6} Torr. *The residual thrust is several orders of magnitude larger than the remaining ambient ionization can account for.*

Going further in your letter of January 28th, the condenser "Gravitor" as described in my British patent, only showed a loss of weight when vertically oriented so that the negative-to-positive thrust was upward. In other words, the thrust tended to "lift" the gravitor. Maximum thrust observed in 1928 for one gravitor weighing approximately 10 kilograms was 100 kilodynes at 150 KV DC. These gravitors were very heavy, many of them made with a molded dielectric of lead monoxide and beeswax and encased in bakelite. None of these units ever "floated" in the air. There were two methods of testing, either as a pendulum, in which the angle of rise against gravity was measured and charted against the applied voltage, or, as a rotor 4 ft. in diameter, on which four "gravitors" were mounted on the periphery. This 4 ft. wheel was tested in air and also under transformer oil. The total thrust or torque remained virtually the same in both instances, seeming to prove that aero-ionization was not wholly responsible for the thrust observed.

Voltage used on experiments under oil could be increased to about 300 KV DC and the thrust appeared to be approximately linear with voltage.

In subsequent years, from 1930 to 1955, critical experiments were performed at the Naval Research Laboratory, Washington, D.C.; the Randall-Morgan Laboratory of Physics, University of Penna., Philadelphia; at a field station in Zanesville, Ohio, and two field stations in Southern California, of the torque of multi-segmented rotors containing hi-K dielectrics. The torque was measured continuously day and night for many years. Large magnitude variations were consistently observed under carefully controlled conditions of constant voltage, temperature, under oil, in magnetic and electrostatic shields, not only underground but at various elevations. These variations, recorded automatically on tape, were statistically processed and several sig-

nificant facts were revealed. *There were pronounced correlations with mean solar time, sidereal time and lunar hour angle.* This seemed to prove beyond a doubt that the thrust of "gravitors" *varied with time in a way that related to solar and lunar tides and a sidereal correlation of unknown origin.* These automatic records, acquired in so many different locations over such a long period of time, appear to indicate that the *electrogravitic coupling* is subject to an *extra-terrestrial* factor, possibly related to the universal gravitational potention or some other (as yet) *unidentified* cosmic variable.*"

In response to additional questions, a reply of T.T. Brown, dated April 5, 1973, stated:

"The apparatus which lifted itself and floated in the air, which was described by Mr. Kitselman, was not a massive dielectric as described in the English patent.

Mr. Kitselman witnessed an experiment utilizing a 15" circular, dome-shaped aluminum electrode, wired and energized as in the attached sketch. When the high voltage was applied, this device, although tethered by wires from the high voltage equipment, did rise in the air, lifting not only its own weight but also a small balance weight which was attached to it on the underside. It is true that this apparatus would exert a force of *upward of 110% of its weight.*

The above experiment was an improvement on the experiment performed in Paris in 1955 and 1956 on disc airfoils. The Paris experiments were the same as those shown to Admiral Radford in Pearl Harbor in 1950.

These experiments were explained by the scientific community as due entirely to "ion-momentum transfer," or "electric wind." It was predicted categorically by many "would-be" authorities that such an apparatus would not operate in vacuum. The Navy rejected the research proposal (for further research) for this reason. The experiments performed in Paris several years later, proved that ion wind was not entirely responsible for the observed motion and *proved quite conclusively that the apparatus would indeed operate in high vacuum.*

Later these effects were confirmed in a laboratory at Winston-Salem, N.C., especially constructed for this purpose. Again continuous force was observed when the ionization in the medium surrounding the apparatus was virtually nil.

. . . In reviewing my letter of April 5th I notice, in the drawings which I attached, that I specified the power supply to be 50 KV. Actually, I should have indicated that it was 50 to 250 KV DC for the reason that the experiments were conducted throughout that entire range. The higher the voltage, the greater was the force observed. It appeared that, in these rough

*The reader is referred to the chapter "THE CASE FOR THE ETHER."

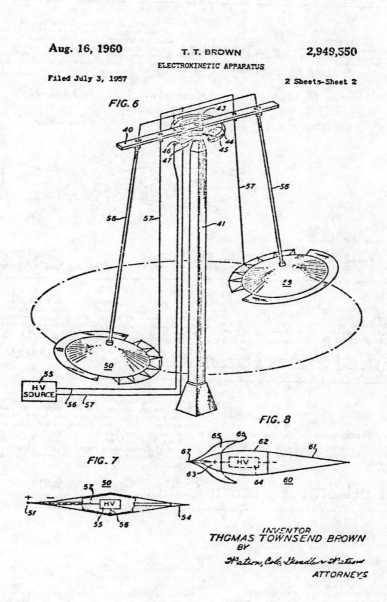

Aug. 16, 1960 T. T. BROWN 2,949,550

ELECTROKINETIC APPARATUS

Filed July 3, 1957 2 Sheets-Sheet 2

FIG. 6

FIG. 8

FIG. 7

HV SOURCE

HV

HV

INVENTOR
THOMAS TOWNSEND BROWN
BY
Watson, Cole, Grindle & Watson
ATTORNEYS

United States Patent Office

3,022,430
Patented Feb. 20, 1962

1

3,022,430
ELECTROKINETIC GENERATOR
Thomas Townsend Brown, Umatilla, Fla., assignor to
Whitehall-Rand, Inc., Washington, D.C., a corporation
of Delaware
Filed July 3, 1957, Ser. No. 669,727
18 Claims. (Cl. 310—5)

2

source connected between the body and the electrode, a
collector screen positioned in the path of the nozzle for
collecting the charged particles delivered by the fluid
stream from the electrode and a circuit connected between
the collector screen and the body for converting the high
direct current voltage developed between the screen and
the body to a low direct current voltage.

Feb. 20, 1962 T. T. BROWN 3,022,430
ELECTROKINETIC GENERATOR

Filed July 3, 1957 2 Sheets—Sheet 1

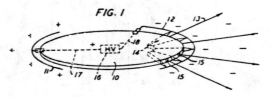

FIG. 1

United States Patent Office

3,187,206
Patented June 1, 1965

1

3,187,206
ELECTROKINETIC APPARATUS
Thomas Townsend Brown, Walkertown, N.C., assignor,
by mesne assignments, to Electrokinetics, Inc., a cor-
poration of Pennsylvania

2

trode of special configuration whereby the electric lines-
of-force are made to converge at a distance from the
electrode. One illustrative embodiment of this invention
which satisfies the above requirement is an arcuate sur-
face or, alternatively, a system of wires, tubes or plates

United States Patent Office

2,949,550
Patented Aug. 16, 1960

1

2,949,550

ELECTROKINETIC APPARATUS

Thomas Townsend Brown, Umatilla, Fla., assignor to
Whitehall-Rand, Inc., Washington, D.C., a corpora-
tion of Delaware

2

for producing relative motion between a structure and
the surrounding medium which apparatus includes a pair
of electrodes of appropriate form held in fixed spaced
relation to each other and immersed in a dielectric me-
dium and oppositely charged.
It is another feature of my invention to provide ap-
paratus which includes a body defining one electrode, an-
other separate electrode supported in fixed spaced relation
by said body, and a source of high electrical potential con-

United States Patent Office

3,018,394
Patented Jan. 23, 1962

1

3,018,394
ELECTROKINETIC TRANSDUCER
Thomas Townsend Brown, Umatilla, Fla., assignor to
Whitehall-Rand, Inc., Washington, D.C., a corporation
of Delaware

2

electrical transducer which includes pairs of electrodes
connected in groups, certain of the groups being con-
nected in polarity opposition with respect to certain other
of the groups, a source of high voltage connected to each
of the groups.

tests, that the increase in force was approximately linear with voltage. In vacuum the same test was carried on with a canopy electrode approximately 6" in diameter, with substantial force being displayed at 150 KV DC. I have a short strip of movie film showing this motion within the vacuum chamber as the potential is applied."

Kindest personal regards,

Sincerely,

T. Townsend Brown.

APR 5 - 1973

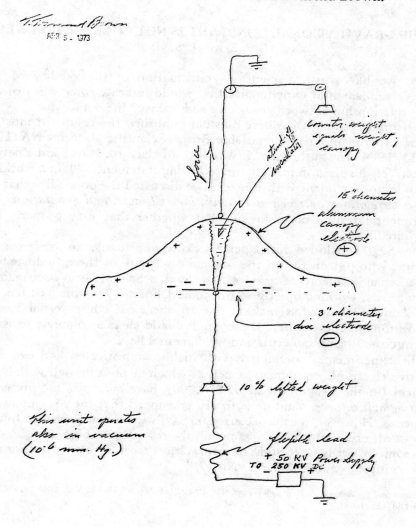

THE GRAVITATIONAL CONSTANT IS NOT CONSTANT AT ALL!
(Dr. Erwin J. Saxl)

Do we have further scientific confirmation of the validity of T. T. Brown's fundamental experiments that would indicate some form of interacting relationship between electricity and gravity? Indeed we do!

A former student of Albert Einstein published the results of most convincing experiments in the reputable British Scientific Magazine NATURE,* July 11, 1964. The author, Dr. Erwin Saxl, of Harvard, Mass., and a native of Austria, felt justified in making the following statement:—"When working as a post-doctoral student with Einstein, we discussed the possibility that there were *interrelations between electricity, inertial mass, and gravitation.* These experimental results make me wonder whether they may properly be so interpreted."

Dr. Saxl concluded his paper by expressing thanks to Professor Hans Thirring, who put on record the original disclosure of these findings before the Austrian Academy of Sciences. Dr. Saxl, a balding, heavy-set man with bushy brows, working quietly in his home laboratory for the past ten years, is well aware that he is making one of the most controversial scientific propositions of the century. If proven, it would mean a complete revision of current cosmological concepts and fundamental laws.

His experiments, conducted with highly sophisticated and exquisitely sensitive electronic equipment, much of which he built himself with his own finances (in the neighborhood of $50,000), have indicated the presence of *electro-gravitic forces*—and he is firmly convinced that the equipment is not erroneous. However, partly because Dr. Saxl's work was privately financed, and not officially authorized or funded, the results were brushed aside—by at least some officials, according to information received by the author of this book—with the caustic remark, "Nutty!"

*An Electrically Charged Torque-pendulum, Dr. Erwin J. Saxl, NATURE, Vol. 203, July 11, 1964, p. 136-138, (England).

For the lay reader, a short description of the research results was published by the Boston Sunday Globe, Boston, Mass., June 14, 1964, under the heading, "Gravity Not Constant, Einstein Pupil Makes Discovery."

The report starts as follows:—"A one-time pupil of Albert Einstein has obtained experimental evidence that upsets one of the most firmly established concepts of modern physics, the Boston Globe and North American Newspaper Alliance have learned. He has found that the so-called 'gravitational constant'—a number heretofore believed to be unchanging—*appears to vary under dynamic conditions.* At the same time he has found evidence that gravity and electricity, until now believed completely unrelated, *do in fact interact.* If his experiments are confirmed, it will mean rewriting the books from start to finish. In sum, it will be one of the most important scientific discoveries in history, on a par with Newton's laws of gravity and Einstein's theories of relativity, adding a completely new dimension to both their concepts of the Universe." . . . "This is the first time" concluded the paper, "gravitation and electricity have been connected experimentally, and if the evidence could be confirmed its scientific import would be staggering."*

" 'It would make possible, finally, a completely unified picture of the Universe,' states Dr. Saxl flatly."

We may safely assume that this news reporter had never heard of T.T. Brown's experiments. Nor, apparently, did he know of Michael Faraday's statement given in a lecture to the Royal Academy on November 28, 1850—more than 125 years ago—: "Here end my trials for the present. The results are negative. *They do not shake my strong feeling of the existence of a relation between gravity and electricity, though they give no proof that such a relation exists."* (M.F., Philosophical Transactions, London, MDCCCLI, 1-6 Paragraphs 2702-2717).

Over the years, certain exceptions to Newton's Laws of Gravitation have been found which were largely resolved and accounted for in Einstein's relativistic concepts. But even now, serious flaws exist in the *current theoretical framework* of our Universe. According to Newton, any two bodies in the Universe attract each other with a definite force that can be calculated by a constant immutable law. But now Dr. Saxl's experiments—undertaken under unique conditions—suggest something completely different.

On the one hand, in the macrocosm of space, if the gravitational laws are valid, scientists are hard put to explain how the Universe could be expanding, as the so-called "red shift" makes it appear. Distances notwithstanding, the masses of entire galaxies are so enormous that they should have no choice but to contract.

On the other hand, in the microcosmic world of atomic nuclei, the

*Gravity Not Constant, Einstein Pupil Makes Discovery, Boston Globe, Boston, Massachusetts, June 14, 1964 (USA).

distances between particles are so small that, in spite of the tiny masses, the nucleus should theoretically collapse.

Thus, while Newton's laws describe very nicely what goes on in the medium range, of sun and planets, missiles and space probes, at the extremes of large and small they run into trouble.

By introducing the concept of *dynamic interaction between electricity and gravity,* we come upon a new and breathtaking view, which could explain a great deal! In essence, what Dr. Saxl did is this: Instead of testing the gravitational constant in a motionless system, he set about to study it under *dynamic conditions.* He built a system which permitted a huge ceramic disc to rotate freely from a solid suspension, specifically designed and constructed to prevent vibration or any outside interference. Then he found a way of regenerating the rotation of this "pendulum" electronically under exceedingly precise control. Finally, using a light beam and a photo-electric cell, he succeeded in measuring the time it took the pendulum to swing over a certain arc with an accuracy of *one part in 10 million!*

Putting his system to work in the middle of the night, to avoid as much disturbance as possible to his incredibly sensitive instruments, he determined whether a pendulum, given precisely the same starting impulse every time, would take exactly the same amount of time to swing over its arc. Since the *mass* of a pendulum does not change, the swing of the pendulum should be strictly a function of gravity, and, according to Newton's law, should not change. But—Saxl found—it does!

Groping for the answer to the variations he obtained in the gravitational force as reflected in the movement of the pendulum, he decided to see what would happen if the pendulum were charged with electricity. In his own words, "All hell broke loose!" Specifically, he found that when the pendulum is charged *positively,* it takes longer to swing through its arc than when it is charged *negatively!*

Extensive additional experiments with his instruments indicated that *there is a definite relationship between gravity and electricity,* an association which had never before been made. This means, since the mass of the pendulum does not change, that the electricity must be *interacting* in some manner with the "force of gravitation" to influence the length of the swing.

"In space we know there are billions of electron volts, and we're dealing with masses of fantastic magnitude," observes Dr. Saxl. "If my little pendulum, moving over such tiny distances and with such modest voltages shows a distinct electro-gravitic effect, what forces may be operating in intergalactic space where the parameters are multiplied infinitely in both electric charge and mass?"

Likewise, in atomic structure, electro-gravitic forces may be playing a crucial role. Specifically, the apparently enormous concentrated mass of a

nucleus may well be much smaller than now caluclated, as a result of *electro-gravitic interaction*. This would be an entirely satisfactory explanation for why they do not collapse.

Dr. Saxl concludes that one possibility is that the Universe is permeated by "electro-gravitic force fields," which influence the speed of light traveling millions and millions of light years through space and produces the red shift. Thus, the Universe may only *appear* to be expanding—though in reality it is not.

"It will be hard for many scientists to swallow this," he told the Globe, "just as it is hard for them to accept any new experimental findings of a fundamental nature. But I know Einstein, for one, would have welcomed this experimental evidence with open arms. Back in Berlin he once told me that he'd give anything to find some precise factors tying gravitation in with electricity!"

A great deal has happened since the report appeared in the Boston Globe. Major improvements were made in the system of instrumentation of the data recorded automatically and fed into an IBM 370 computer. The observations proceed without manual monitoring. The isoelastic suspension wire is kept at a constant temperature. With the long runs thus made possible, periodicities are uncovered. Variations in period which have been consistently observed for many years continue to appear. *These may require an extension of present gravitational theory,* claims Dr. Saxl.

He also discussed his research with the late Dr. James E. McDonald. In a private communication, he states: "I was sorry to learn about the demise of Dr. McDonald. He was in my darkroom. He saw the instruments together with some reprints and extensive data in some of my note-books. He was most encouraging."

Dr. Saxl's experiments continue to shake the foundations of contemporary dogma. So his fellow-scientists look tactfully the other way, pretending they do not exist.

"AN ENTIRELY NEW DISCOVERY IN FUNDAMENTAL PHYSICS. . ."

PROJECT OUTGROWTH:
Advanced Propulsion Concepts

PROJECT OUTGROWTH is the open technical report AFRPL-TR-72-31, dated—June 1972, by a special group of 28 members of the U.S. Air Force Systems Command, Edwards, California, attempting to predict major propulsion developments in the near future. The report deals with advanced concepts like *"field propulsion"* in order to define their potential. A summary closes with the significant statement that the report was "designed to encourage and motivate talented and interested scientists and engineers once again to strive for 'advanced propulsion concepts'." Among others, the following selected categories are listed on field propulsion:

Electrostatic Effects
Alfven Wave Propulsion
Electromagnetic Spacecraft Propulsion
Superconducting Particle Accelerator
Antigravity Propulsion

Field Propulsion concepts are those which use electric and/or magnetic effects. It is in the area of field propulsion that the *most revolutionary concepts appear.* "The ability to perform objective analyses of many of these ideas was diminished because underlying principles governing transition from the known to the unknown are obscure. The category of field propulsion probably contains more ideas than any other concept area."

The section titled: *Antigravity Propulsion* describes the control of gravitational forces of the earth and other celestial bodies as a method of propulsion and lists as its main attributes:

1. Infinite specific impulse
2. Near speed of light velocities attainable
3. Minimum damage to environment
4. Economic exploitation of space

The report notes, "Before attempting to control gravity, it will be necessary to know *exactly what causes gravity.* Many reputable scientists, including Michael Faraday, Max Born, and Albert Einstein, have attempted to explain this phenomenon by relating electromagnetic and gravitational forces. Other scientists are convinced that an *entirely new discovery in fundamental physics* is necessary for a full understanding of gravity. Physicists generally *assume* a relationship between electromagnetism and gravity because both obey the inverse-square law which says that the force of both fields decreases with the distance in the same mathematical relationship."

"There are some intriguing differences between the two forces, however, since electromagnetism consists of two identifiable components,—an electrical field and a magnetic field—while, gravity appears to have only one component. In addition, electrical charges can repel and attract, while gravity always attracts."

As the French mathematical physicist Borel wrote, "There was, however, something rather strange in this phenomenon of gravitation, something that distinguished it from other physical phenomena. This was its utter immutability and its absolute independence of all external actions. Light is arrested by opaque bodies, deviated by prisms and lenses; electrical and magnetic actions are modified by the neighborhood of certain bodies; gravitation alone remains always the same . . ."

HONESTLY NOW: WHAT *IS* GRAVITATION?

"I would expect the next decade of research to be as momentous for gravitational theory as the decade 1925-1935 was for the Quantum Theory."

(Dr. J.W. Gardner, 1969)

Although taken for granted by all of us, gravity is a mysterious force if there ever was one. It is under constant scrutiny by searching scientists. Present—day concepts include gravitational waves, gravitons and comparable theories. The "Gravity Research Foundation" in the USA, a "European Center for Gravitational Research" and similar organisations and foundations are attempting to solve the riddle surrounding this force with the hope to—perhaps—eventually control it. Millions of schoolchildren all over the world have learned for generations:

"The laws of gravitation are well known and were firmly established by Sir Isaac Newton" (1642-1727).

Einstein's general theory of relativity describes gravity as a field influence in universal space but also failed to identify the *cause* of gravity. Interestingly enough, Isaac Newton himself tried to be most careful in denying any "cause" in these laws. His laws of gravity, by now about 300 years old, accurately describe the effects of this universal force in a broad spectrum, without mentioning anything about its *causes*. In his famous book "The Mathematical Principles of Natural Philosophy," usually referred to as "The PRINCIPIA," he stated emphatically:

"For I here design only to give mathematical notion of those forces without considering their physical cause and seats."

56

And in another context, he stressed again:

"You sometime speak of GRAVITY as essential and inherent to matter. *Pray do not ascribe that notion to me; for the cause of gravity is what I do not pretend to know.*"

Despite Newton's expressed caution about the cause of gravity, it soon became the custom to call the inverse square relationship between objects the law of gravitation. And when the chips were down during the critical moments of the near—tragic, aborted Apollo 13 moon voyage when the vehicle traced a curved line trajectory prior to re-entry into the earth's atmosphere, the world held its breath as Mission Control in Houston asked, "Who is guiding the ship?" With assuring calm, astronaut James Lovel replied, "Sir Isaac Newton."[*]

Newton did associate gravity with the mass measure of particles and the magnitude of this attraction between all bodies of matter is said to be directly proportionate to the square of the distance between them. The resulting formula in its original form is the well-known: $G = \frac{M_1 \times M_2}{d^2}$

The attraction between the earth and an object near its surface is an example of this universal force, commonly described as being the "weight" of the object.

However, there is a difficulty in the mathematics of Newton's formula and the implication of that has been brought out in a challenging intellectual experiment, conducted by Dr. Daniel W. Fry in his book "Atoms, Galaxies and Understanding," which is quoted here with permission by the author of that book:[**]

"The difficulty with the statement that the force varies inversely as the square of the distance lies in the implication that if the distance (between two objects) becomes zero, the force (of gravity) should become infinite. Thus it would at first seem that a man standing or lying upon the surface of the earth would be one of two bodies between which the distance was zero, therefore, the weight of the man should be infinitely great. The reply to this assumption is that the force *acts as though* it originated at the center of the mass, called the "Center of Gravity," and that the man on the surface of the earth is still some four thousand miles from its *center of gravity*.

This explanation, however, creates a new problem in that, if we accept it literally, we must assume that if there were a well or shaft extending to the center of the earth, and if a man descended this shaft, his weight would increase as he approached the center of gravity, becoming infinite as he reached it.

[*]"The Little Book," by Otto Luther, Key Research Corp, Box 100, Yorba Linda, Calif. 92686.

[**]*Atoms, Galaxies and Understanding*, by Daniel W. Fry, Ph.D., 1960, Understanding Publishing Co., Box 181, El Monte, Calif. (USA)

Actually, of course, his weight would *decrease*, becoming zero when his center of gravity coincided with that of the earth. So we are forced to the further explanation that gravity is inherent, not in "bodies," but in particles of matter, and since the man at the center of the earth would have an equal number of particles attracting him from every direction, the resultant of the forces would be zero.

If we assume the gravity to reside independently within each atom, our problem is solved as far as the man and the earth are concerned, but if we look within the atom itself in the attempt to find the point where the distance becomes zero, and the force infinite, we find that the same problem again confronts us. We have not solved it, we have only changed our scale of observation."

It appears from the foregoing that if we really want to find the *cause* of gravitation, we will have to examine the inside of the atom, the *atomic nucleus* more closely! We have shown that Newton was unable to furnish an answer to this problem. And when Einstein attempted to develop a Unified Field Theory that would include gravitational phenomena, he failed to succeed. We know from Einstein's book, "Mein Weltbild" what he was searching for:

"It would of course be a great step forward if we succeeded in combining the gravitational field and the electro-magnetic field into a single structure. Only so could the era in theoretical physics inaugurated by Faraday and Clark Maxwell be brought to a satisfactory close."

Einstein died in 1955, before he was able to develop the Unified Field Theory.

It took more than ten years after his death until an American and a German scientist, both working independently, came up with a satisfactory explanation for the origin of the force we are accustomed to call "gravitation."

And both men were ignored by official science!

MEANWHILE — BACK IN EUROPE

The Non-Existence of the Ether

Claim:—Michelson disproved the existence of the "Ether" by the celebrated Michelson-Morley experiment of 1887.

Facts:—This most famous experiment-that-failed in the history of science was based on the *assumption* that the ether was motionless in space. It was therefore *assumed* that the earth, in its motion around the sun, must be *passing through* the motionless ether and, as a consequence of its motion, there must be an ether wind blowing past the earth at all times. The calculations were carried out under the assumption that the velocity of light and the velocity of the ether wind could be added as vectors. Contrary to public opinion, it is to be noted that *no one* advanced the idea at that time that the ether perhaps did not exist at all. The experiment merely proved the non-existence of an *ether-wind*.

In Reuterdahl's comment on Einstein, published in the Minneapolis Morning Tribune of April 14, 1923, p. 21, Michelson is quoted as saying that even if relativity is here to stay *we don't have to reject the ether*. Material on the Einstein controversy is contained in box No. 116 of the papers of Dr. T.J.J. See at the Library of Congress, where it was verified by Prof. Stephen G. Brush of the Institute for Fluid Dynamics and applied Mathematics of the University of Maryland, in 1976. (From a private communication of Prof. Brush to Mr. C.B. Wynniatt, Whangarei, New Zealand).

When Michelson was awarded the Nobel Prize in physics, 1907, it was for his optical studies generally, and *not* for "disproving the ether-concept," as is sometimes claimed. He was the *first American* to win a Nobel Prize in science.

THE CASE FOR THE ETHER

"The aetherless basis of physical theory may have reached the end of its capabilities and we see in the aether A NEW HOPE FOR THE FUTURE."

Prof. P.A.M. Dirac, 1954/Nobel Prize in physics 1933.

"By his willingness to change his model or his concepts, the scientist is admitting that he makes no claim to possessing ultimate truth."

Dr. Wernher von Braun

Progress in science occurs when new facts have been discovered, and their contradiction with the respective contemporary theory has been recognized. Then the newly emerged facts become explainable by a new and extended theory and the old theory is discarded.

One theory of fundamental importance in science is the controversial theory of the *non-existence* of ETHER. The term "ether" stems from Aristotle's name for the fifth element that he considered to make up the heavens, a component of all objects outside the earth's atmosphere. (The other four elements were fire, water, earth and air, and these were restricted to the earth itself.)

Early wave physicists postulated an 'ether' filling space and all transparent substances. Light consisted of waves in this ether, which thus carried light even through an apparent vacuum and was therefore called a luminiferous or "light-carrying" ether.*

James Clerk-Maxwell defined ether as "a material substance of a more subtle kind than visible bodies, supposed to exist in those parts of space which are apparently empty." Newton employed the term for the medium

*Asimov, Isaac, *Biographical Encyclopedia of Science and Technology*, Garden City, New York: Doubleday & Co., 1964

which fills space, including the space which appears to be occupied by matter; for to him *the ether* must also penetrate between the atoms, in the pores of matter. Clerk-Maxwell summed it up with the opinion: "Whatever difficulties we may have in forming a consistent idea of the constitution of the aether, there can be no doubt that the interplanetary and intersteller spaces are not empty, but are occupied by a material substance or body, which is certainly the largest, and probably the most uniform body of which we have any knowledge."*

However, the concept of ether is by no means only a hypothesis of 19th century scientists. Many modern scientists, including Tydal, Bertrand Russell, C.W. Richardson, Carl F. Krafft, and Sir Arthur Eddington, have affirmed their belief in the existence of the ether.

The crucial test to prove or disprove its existence was based on an assumption, an erroneous assumption as we shall see. It was believed that the ether was motionless and that the earth traveled through it. A light beam sent in the direction of earth's motion ought therefore to travel more rapidly than light sent at right angles to it. The two beams of light ought to fall out of phase and show interference fringes. Albert A. Michelson's first experiment in 1881 showed no interference fringes; neither did the second and much more elaborate experiment in 1887. The absence of an ether wind was equated with the absence of ether.

Although a scientific theory was derailed, the attempts to bury it once and for all have failed.

The Conceptual Necessity of Ether and Early Experiments

"If waves setting out from the sun exist in space eight minutes before striking our eyes, there must be in space some medium in which they exist and which conveys them. Waves we cannot have, unless they be waves in something." This view expressed by Sir Oliver Lodge was the generally held opinion of his time. "The ether is a physical thing!" claimed Lodge; he explained further, "The ether is dealt with not as a rarefied essence but as a substance with ascertainable physical properties, to which the ideas usually and properly associated with the word 'ethereal' are foreign."

One basic experiment showed the elasticity of the elusive ether, a property which was interpreted by Lodge: "We have no means of getting hold of the ether mechanically; we cannot grip it or move it in the ordinary way: *we can only get it electrically. We are straining the ether when we charge a body with electricity; it tries to recover, it has the power of recoil*"**

*Lodge, Sir Oliver, *The Ether of Space*, New York: Harper & Bros. 1909
**Ibid.

"WE CAN ONLY GET IT ELECTRICALLY"

The experiment was initiated in the middle of the 19th century by the Frenchman Gassiot, who made the first unsuccessful attempts to pass electricity through rarefied gases. After him, Plücker invented the tube used later by Geissler for his experiments, from which the name "Geissler tube" is derived. Other scientists of world fame, like Crookes, carried out experiments with success, resulting in considerable progress in the field of physics. Crookes proved the mechanical action of "cathode rays" of bombarding rotary blades within the evacuated tube with these rays and setting the blades in motion.

(In a Geissler tube, the atmospheric pressure is reduced to between 1 and 3 mm. of mercury. If the tube contains air and the anode and cathode ends of it are put into contact with the positive and negative poles of a high-voltage electric current, the whole tube lights up with a violet light, with the exception of a space at the cathode end where the light is blue and separated from the violet light by a dark band. When a "Geissler tube" is placed in the field of an electromagnet, the fluorescent glow shifts its position. The shift alters its direction when the poles of the magnet are reversed. This was the first tentative move in the direction of subatomic particles.)

There was one great difficulty with these cathode rays; they were unable to leave the tube of rarefied air since they were incapable of passing through glass. Hertz had discovered that cathode rays could penetrate thin layers of metal, and it was then that Philipp Lenard (Nobel Prize winner in physics in 1905), continuing on Hertz's previous experiments, made an aluminum "window" on the side of the vacuum tube opposite to the cathode. Through this window the rays were projected outside the tube, where they could be studied with ease in the open air. He proved that these "Lenard rays" could be propagated in the atmosphere, causing atmospheric phenomena similar to those inside the tube. The passage of electrons through the dense air of the atmosphere appeared to open a tunnel in which considerable air turbulence and luminous effects, varying according to the voltage used, were observed.

The German physicist Eugen Goldstein studied the luminescence produced at the cathode. In 1886, by using a perforated cathode, he discovered that there were also rays going through the channels in the direction opposite to that taken by the cathode rays. He called these *Kanalstrahlen* ("channel rays" also called "canal rays" or "positive rays"). The study of these rays led eventually to the recognition by Rutherford of the existence of the proton, while J.J. Thomson, who supplied the final proof of the existence of particles in cathode rays, is usually considered the discoverer of these particles, our electrons.

Evidently, some important papers of the Germans—Geissler, Plücker,

Hertz and Lenard never found their way into the English scientific literature, and we are indebted to the late Dr. Kurt Seesemann for the following information, published in Switzerland in 1956 under the title "Aetherphysik und Radiaesthesie" ("Etherphysics and Radiesthesia"). According to Seesemann, Philipp Lenard undertook a crucial experiment to prove the existence of the ether by having a second Plückertube with an aluminum window connected by a glassblower to the window of the first tube, and evacuating both tubes. His argument was that if ether really did *not* exist, both the cathode rays and the canal rays should show identical behavior in both tubes: the first one, where they originated, and the second, which allowed them access via the aluminum window. Alas, only the cathode rays entered the second tube, and Lenard concluded that the vacuum of space permitted transmission of only the negatively ionized rays, thus indirectly proving the existence of a transmitting ether between the sun and our planet.

In the same paper, Dr. Seesemann shows that Einstein revoked his stand on the non-existence of ether in 1952 (shortly before his death in 1955) after the British Nobel Prize winner Dirac at the University of Cambridge "proved the actual existence of ether by mathematical means."* Quite evidently, Einstein had repeatedly changed his opinion on the subject of ether. In his book *Ether and Reality* (1925), Sir Oliver Lodge quotes Einstein from his paper "Sidelights on Relativity" as follows: "There is (sic) weighty arguments to be adduced in favour of the ether hypothesis. To deny the ether is ultimately to assume that empty space has no physical qualities whatever. The fundamental facts of mechanics do not harmonize with this view . . . According to the general theory of relativity, space is endowed with physical qualities; in this sense, therefore, there exists an ether. According to the general theory of relativity space without ether is unthinkable"**

In contrast to the claims by Sir Oliver Lodge and Dr. Seesemann, Isaac Asimov merely states, in connection with the ether question, that Einstein had "cancelled out the ether as unnecessary by assuming that light traveled in quanta and therefore had particle-like properties and was not merely a wave that required some material to do the waving . . ."***

The same reference source describes very briefly the work of Sir Oliver Lodge, neglecting to mention at all his deep involvement in ether research, and concluding with the rather nasty remark: "He (Sir Oliver Lodge) became a leader of 'psychical research' and is one of the prime examples of a serious scientist entering a field that is usually the domain of quacks."

The most important contribution to the ether controversy in modern times seems to come from an Italian, Professor Marco Todeschini of the

*Congres Mondiale de Radiesthesie, *Livre de Rapport*, Locarno, Switzerland, 1956
**Lodge, Sir Oliver, *Ether and Reality*, London: Hodder & Stoughton, Ltd., 1925
***Asimov, op. cit.

Theatine Academy of Sciences, Physics Branch, a recent contender for the Nobel Prize.

In a foreword to Todeschini's book, the President of the Academy, Mr. Angelo De Luca, points out that in March 1956, at the 25th International Convention of the American Society of Physics, the scientist Oppenheimer revealed that the behavior of anti-particles and the occurrence of sub-atomic phenomena are in sharp conflict with Einstein's relativity, and in harmony with Galilei's. The return to classical physics, says the President, should therefore be needful: " . . . the conclusion that it is Galilei's relativity and *not* Einstein's which is found in the Universe . . . allows modern theoretical physics to eliminate all its uncertainties and antitheses, proceeding on a ground of solid reality and opening wide horizons to scientific progress and its practical application."

Considering Michelson's experiment and Bradley's astronomical aberration, discovered in 1728, Professor Todeschini reaches these conclusions: "A motionless ether exists in the whole Universe. It exists, but in proximity of the Earth *it moves jointly with it* in its revolutionary (rotating) movement round the Sun." If this is actually the case, the negative outcome of Michelson's experiment finds an explanation.

Instead of a weightless ether, as until now conceived by physics, Todeschini postulated a fluid space possessing a constant density.

From this theory, he was able to demonstrate that "the Sun is located in the center of a huge spheric field of fluid rotating space, which moves subdivided like an onion in many concentric layers having constant thickness and rotation speed diminishing with the increase of the square roots of their radiuses. From my theory it also follows that the Earth is located in the center of a similar smaller rotating field, placed at the periphery of the bigger solar one." Todeschini has conducted numerous tests to back up his claim, and the science-oriented reader will have to read his books in order to comprehend his conclusions.

Returning to Michelson's experiment, Todeschini notes that it was based upon the assumption that the ether is motionless throughout the universe; but, he continues, "I have demonstrated . . . that our planet in its revolution movement *drags with itself* its surrounding medium of ether *just as it carries along its atmospheric quilt,* and this makes us certain that the Earth is in the center of an ether's planetary sphere and that both turn around the Sun with the same speed revolution of 30 Km/sec."[*]

If we return for a moment to Sir Oliver Lodge, we will find the following statement: "Mr. Michelson reckons that by his latest arrangement he could see 1 in 4,000 millions if it (the ether drift) existed; but he saw nothing.

*Todeschini, Marco, *Decisive Experiments in Modern Physics*, Bergamo, Italy: Theatine Academy of Sciences, 1966 (Translated from the Italian)

Everything behaved precisely as if the ether was (sic) stagnant; *as if the earth carried with it all the ether in its immediate neighborhood.** Lodge's conceptual theory is confirmed not only by the claims of Todeschini, but also by a Brazilian scientist with the pseudonym of Dino Kraspedon, whose book was translated into English in 1959 (Neville Spearman, Ltd., London, England). This information source states that, pertaining to Michelson's experiment of ether drift:

> "He found none, nor could it be found. The retardation which he thought to find in the speed of light, owing to the resistance of the ether, could not exist if the ether moves with the same angular velocity as the Earth. When two bodies develop identical velocity in the same direction, they remain in the same relative positions. It does not matter what the speed is to an observer outside the system; it is a question of relative velocity between two points in the same system . . . However, Michelson is not to be blamed. The blame lies with those who thought that the ether was universal and *stationary in relation to Earth.* On this false premise, anybody would have come to the same erroneous conclusion. If a minor premise in a syllogism is wrong, the conclusion is wrong, just as it is if a major premise is involved. False theories produce wrong results. As far as that experiment was concerned, it was a false premise on which the people of Earth have elaborated a whole theory."

It becomes apparent that Sir Oliver Lodge (an Englishman), Marco Todeschini (an Italian) and the information source of the Brazilian Dino Kraspedon are in full agreement on the important question of the existence of the ether, which is carried around by the Earth, in just the same way as the atmosphere is.

According to the Brazilian information source the etheric covering of our planet extends 400,822 km. beyond the solid surface of planet Earth, and our moon lies within the fringe area of this gigantic ether shell. The ether is described as an 'electric fluid' forming the primary substance and the substratum for electrons and protons, for all physical things and phenomena.

The result of the studies of Sir Oliver Lodge, Professor Todeschini and Dr. Seesemann, coupled with the above-mentioned claims of Kraspedon, point to a gigantic scientific fallacy, resulting in false conclusions in contemporary physics: "All those (new) experimental results," states Todeschini, "*deny* the postulate of light's constant speed, put as the basis of physical theories since 1905 until nowadays, and make us certain that such theory does not correspond to physical reality."

"The result of all the optical experiments (by Todeschini) prove to us that light's speed is relative to the chosen reference system, as is the speed of

*Lodge, *The Ether of Space*, op. cit.

anything else in movement." Todeschini continues to shoot holes in contemporary theories by stating that " . . . bodies' shrinkage and times' dilation predicted in Lorentz's transformation equations and forming the basis of Einstein's pseudorelativity do not happen at all in natural reality; actually, they were postulated (as we have shown) following an erroneous physical interpretation both of astronomic aberration and of Michelson's experiment."*

The theories of Einstein, Heisenberg and Schrödinger appear very questionable if the existence of the ether can be verified, and it will not be an easy task to show the obsolescence of all those accepted physical theories. A coming re-evaluation will prove the truth of Max Planck's statement, "A new scientific truth does not triumph by convincing its opponents and making them see the light, but rather because its opponents die and a new generation grows up that is familiar with it."

Edgar Cayce repeatedly mentioned air ships at the time of Atlantis which were able to navigate "without the use of wings" (195-70) and which were propelled by the application of electrical forces.

Present earthly technology is limited to the application of jet-and-rocket propulsion, but the elusive "Unidentified Flying Objects" (UFOs) exhibit many characteristics of Edgar Cayce's aircraft at the time of Atlantis. Films and photographs of such objects show their absence of wings, and there have been countless reports of magnetic and electrical disturbances connected with their flight over populated areas. The existence of these objects has been denied because they defy scientific explanation; a similar treatment is being given the results of ether research, unpublicized U.S. patents and experimental results pertaining to the possible propulsion of UFOs.

The reader will recall our statements pertaining to Philipp Lenard's experiment, in which the Lenard rays appeared to open a tunnel in the atmosphere, and Sir Oliver Lodge's claim that *we can only get it* (the ether) *electrically*." The definition of the ether by Dino Kraspedon as an 'electric fluid' does indeed fit the picture of this primary substance of all physical things.

Experimenters with Lenard rays have claimed that they were able to "decompose" oxygen, nitrogen and the other gases which make up the atmosphere and theorized that they were able to revert these elements to their "etheric" condition, thus creating a vacuum in their place.

On the basis of experimental work starting in 1926 and lasting to this day, Thomas Townsend Brown was able to produce thrust by charging an electrical condenser made of special materials; he ultimately was flying spherical, saucer-shaped condensers in a hard vacuum, thus eliminating the orthodox explanation of "electric wind" as the source of the UFOs' propul-

*Todeschini, op. cit.

sion. Quite evidently there cannot be wind, i.e., movement of air, in a vacuum. Brown describes how thrust was achieved in the direction of the positively charged edge of these airfoils:

The objects had no propellers, no jets, no moving parts at all. There were no frictional losses involved. The saving of energy in terms of increased efficiency becomes evident if one considers that the actual, usable energy output of our conventional power stations is only about 34% of the total energy input; thermodynamic losses (converting heat to mechanical action in turbines and dynamos) amount to 45%, not counting so-called heat losses in the system. The energy efficiency of the propulsion system discovered by Brown, depending on a highly charged body with a positive leading edge, is close to 100%! T.T. Brown was granted several U.S. patents* and his work was ignored! The results of his experiments simply did not fit into the scheme of present-day scientific theory, period. Since the ether theory had been tossed out the window, one could not even speculate that Brown's experiments were possibly explainable as "straining the ether," to use the words of Sir Oliver Lodge.

On many occasions, Edgar Cayce referred to an energy which he called "etheric energies" or "aetheronic energies." There indeed are vibrations or energies which have distinctly different properties from those of the electro-magnetic spectrum. Using these vibrations, Dr. Galen Hieronymus has been able to trace the physiological functions of U.S. astronauts circling the moon. This strange energy does not show the usual attenuation characteristics of E/M energies; the strength of the signals does not depend on the distance from the sender. There is good reason to assume that these vibrations of the ether are the basis for practically all so-called psychic phenomena, which are unexplained to this day. This energy has been called: "Eloptic energy" by Hieronymus, "Prana" by Indian metaphysicians, "Orgone Energy" by Wilhelm Reich, "Bio-Cosmic Energy" by Dr. Brunler, "X-Force" by the British scientist Eeman, "Nervous Ether" by Richardson, "Odic Force" by Baron von Reichenbach, "Animal Magnetism" by Mesmer, "Vital Fluid" by medieval alchemists, "Mumia" by Paracelsus, and "Vis Medicatrix Naturae" by medical scientists.

"Eloptic Energy operates in a different *medium*," claims Galen Hieronymus. He elaborates further that this energy can be refracted through a prism and conducted along light rays. It can also be conducted along copper wires, insulated by certain types of materials, and conducted through electronic condensers or capacitors: "The energy from a person can be conducted along light rays and implanted on a light-sensitive film, and again onto a print made from that film. The print can be moved to any distance away from the person, and it will act as a perfect reproduction of the person,

*U.S. Patents No. 3,022,430; 3,187,206; 3,018,394; and 2,949,550, Thomas T. Brown

changing from moment to moment as the person changes. It was this principle that we used in order to follow the astronauts out into space, and test them as they changed due to high 'G' stress and to other influences they were subjected to." These claims could possibly be disregarded as the ravings of a lunatic scientist, were it not for the fact that, around the turn of the century, Professor R. Blondlot in Nancy, France discovered a radiation with exactly the same properties; he named it "N" radiation, after the location in Nancy. The Nobel Prize winning (1903, in physics) French researcher, Professor Jean Becquerel, who was the original discoverer of the phenomenon later called "radio-activity" by Marie Curie, reported the discovery of his "N" rays in a scientific paper in France.* He stressed one outstanding difference with E/M radiation, namely that "N" rays have a very slow speed of propagation along wires. The same fact was confirmed not only by Hieronymus in the U.S., but also by Eeman ("Eeman-circuits") in England and by a German, Dr. med. et phil., Joseph Wuest.**

The incredible importance of research on this particular subject (etherradiations) had been recognized by Rudolph Hess, deputy of Adolf Hitler, who privately financed Dr. Joseph Wuest. This fact was mentioned to this writer by Dr. Wuest personally just a few years ago. Only World War II put an end to his research. If the above statements sound heretical, we should not forget that the heresies of Galileo's day are now universally accepted "scientific facts."

Among the still unexplained phenomena are, for instance, telepathy, which *cannot* be explained by means of electromagnetic hypothesis. The importance of the discovery of the carrier-mechanism of telepathy was described by the Soviet scientist, Vasilyev: "To discover such energy would be tantamount to the discovery of nuclear energy!"

Psychometry is another example of a still enigmatic energy-form which could be explained by the ether theory. The "aka-threads" of the Polynesian Kahuna-priests of old and the fear of some natives to be photographed also come to mind. Spirit apparition becomes explainable as a condensation of the elusive ether by manipulation of so-called spirit entities. The observed drop in temperature at all such occurrences supports the thesis of a transformation of ether-energy to a semi-material substance. The Swiss professor, Eugen Matthias, claims that we are dealing indeed with a "PRE-PHYSICAL STATE OF MATTER,"*** and nothing could describe the nature of ether better than this definition, which is almost identical to that given by Edgar Cayce.

*Becquerel, Jean, In *Comptes Rendues*, Tome 138, p. 1413, Le Roux, France, 1904
**Wuest, Joseph, "About a New Type of Radiation Surrounding All Inorganic and Organic Substances as Well as Biological Objects." University of Munich, 1933-34, (Available only in German)
***Matthias, Eugen, *Die Strahlen des Menschen Kunden sein Wesen*, (The Radiations from Man Proclaim His Whole Being), Zurich, Switzerland: Europa—Verlag, 1955.

Man has walked on the moon, but the basic cause of smell—the physical radiation-transmitting energies of the fragrance of a flower—is still unexplained. Our physical bodies and their behavior patterns cannot be completely explained in terms of conventional atomic and chemical processes. Practitioners of psychosomatic medicine all know that a mind-and-matter relationship holds the key to treating the majority of diseases that beset man today. Could it be possible that the medium in which "mind" functions is the ether? This would explain telepathy, for instance, and make it as easily understandable as a radio transmitter and receiver which are tuned to the same frequency. It would also explain the important effects our thought processes have on the physical world.

Our inadequate knowledge has no answer to the enigma of the pyramid effect, the observed "radiation of form." However, the researchers quoted in this paper have observed that the energy in question can be refracted, reflected, polarized and even focused.* Is it not very possible that the pyramid is an extremely efficient focusing device for the ether? After all, the mummification and dehydration effects of a properly constructed and oriented pyramid are not new discoveries and were not invented by the Czechs or Soviets. They are as old as Egypt and Atlantis.

We cannot ignore the role of the ether, a bio-cosmic energy, as the necessary *link* between mind and matter in all the reported PK phenomena. If we wish to investigate the magic of Uri Geller, we will have to investigate the properties of the ether first. We simply cannot afford to turn the other way if the topics of ether and etheronic energies are repeatedly mentioned in the Edgar Cayce readings. But above all, we cannot afford to continue to ignore the available evidence, resulting from countless years of research, which indicates the existence of the ether and its potential for useful applications in our world.

*Wuest, op. cit.

Note: The material in this section has been published previously by the author under the title: "EDGAR CAYCE and the 'ETHER' Controversy," A.R.E. Journal, Vol. XI, May 1976, No. 3, Association for Research and Enlightenment, Inc., Virginia Beach, Va. 23451

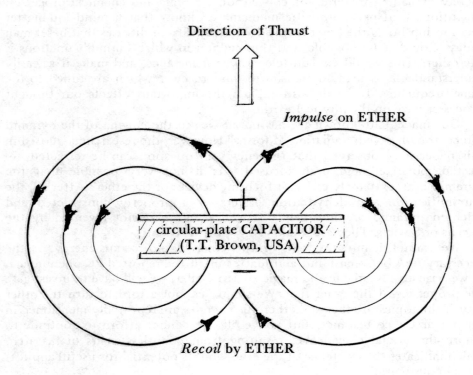

The T.T. Brown Experiment and its relationship to the
universal cosmic energy (ETHER)

"ETHER-VORTEX-TURBINE" IN ENGLAND

"There is a gentleman named John R.R. Searl in England who claims to have developed an anti-gravity device. He is attempting to develop it now into a saucershaped commercial aircraft.

The principle of it is allegedly that, when a metal annulus is rotated at sufficient speed, the conduction electrons are displaced outwards by centrifugal force, so producing a very intense negative charge on the outside perimeter and a positive charge on the inside.

The rotating electric field so obtained can be tapped by induction coils around the annulus to provide current for electromagnets placed in an electric-motor arrangement around the annulus so as to drive the annulus, thus producing a feedback effect resulting in very intense electric and magnetic fields. When the electric potential is about 10^{14} volts, this being conducted to a metal hull around the annulus, shielding from both gravity and inertia is obtained. Because of the shape of the rotor and the need to maximize the charge on the hull, the best shape of hull is like two saucers clamped together at very sharp edge. Directional control is obtained by use of flight coils to produce assymetry in the (force-)field."

(From a private letter of Mr. C.B. Wynniatt,
Professional Engineer,
25 Commins Street, Onerahi, Whangarei,
New Zealand, to the author.)

The following sections of this chapter will attempt to present a scientific overview of the Searl observations and an intelligent analysis of the observed effects.

The Ether—Vortex Turbine by J. Searl, England
(The Barret Report)
issued by P.L. Barret B.Sc.

In 1949, Mr. J.R.R. Searl was employed by the Midlands Electricity Board as an electronic and electrical fitter. He was very enthusiastic about the subject of electricity, though he had no formal education on the subject other than that required by the job. Unhindered by conventional ideas about electricity, he carried out his own investigation into the subject. During work on electrical motors and generators, he noticed that a small EMF was produced by spinning metal parts—the negative towards the outside and pos

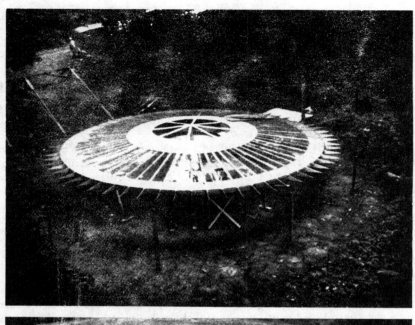

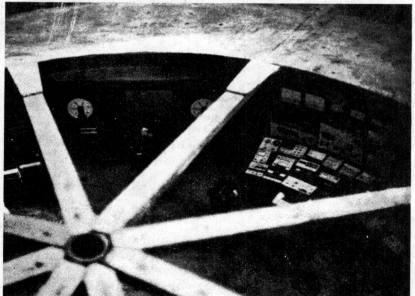

Experimental set-up of the British inventor John Searl

towards the rotational axis. In 1950 he experimented with rotating slip rings and measured a small EMF on a conventional meter. He also noticed that when the rings were spinning freely and no current was taken, his hair bristled.

His conclusions were that free electrons in the metal were spun out by centrifugal force, a centripetal force being produced by the static field in the metal. He decided to build a generator based on the principle. It had a segmented rotor disc, passing through electromagnets at its periphery. The electromagnets were energized from the rotor, and were intended to boost the EMF.

By 1952, the first generator had been constructed and was about three feet in diameter. It was tested in the open by Searl and a friend. The armature was set in motion by a small engine. The device produced the expected electrical power, but at an unexpectedly high potential. At relatively low armature speeds a potential of the order of 10^5 volts was produced, as indicated by the static effects on near objects. A characteristic crackling and the smell of ozone supported the conclusion.

The really unexpected then occurred. While still speeding up the generator lifted and rose to a height of some fifty feet, breaking the union between itself and the engine. Here it stayed for a while, still speeding up and surrounded itself with a pink halo. This indicated ionization of the air at a much reduced pressure of about 10^{-3} mm Hg. More interesting was the side effect, causing local radio receivers to go on of their own accord! This could have been due to ionizing discharge or electromagnetic induction. Finally, and perhaps thankfully, the whole generator accelerated at a fantastic rate and is thought to have gone off into space. Since that day, Searl and others have made some ten or more small flying craft, some of which have been similarly lost, and developed a form of control. Larger craft have also been built—some 12ft., and two 30ft. in diameter. The antics of his machines have given rise to much speculation as to the nature and origin of so-called "flying saucers."

One wonders why Searl has not come to the notice of scientists and the public at large. The fact is that he has; *but for fear of being ridiculed,* people keep the knowledge or interest to themselves. The public has been educated to scoff at the subject of flying saucers, and the reported behavior of the things cannot be explained on current scientific theory. Such "difficult to explain" topics (as with telepathy, dowsing, homeopathic healing, etc.) must be given the "no comment" treatment, so as not to upset the uncertain structure of present scientific theory. Searl's records do show however that his efforts have not gone unnoticed. Government departments and people of all classes and education know about him. Some have attempted to steal the idea, but their thinking along the lines of the electromagnetic theory and the

law of conservation of mass and energy, has misled them or confused them. This narrow thinking has made many conclude that Searl is a crank or imposter. Also some are prejudiced in their attitude that new ideas are the prerogative of a hierarchy of intellectuals.

It is suspected that Searl is to come up with something more momentous than his games with power lines and the unsuspecting motorist. In that event, the conventional thinker must be ready to adapt the Searl Effect into existing theory, or chance the alternative fate of a complete disruption and revisal of physical theory—from Ampere, Galvani and Volta onwards. Any theory must explain these various phenomena, some of which have been observed by Searl himself, and some by the general public:

1. Anti-gravity or levitation.
2. Very high electrostatic fields.
3. The peculiar magnetic effect: The generator produces a "D.C." static field with negative polarity at the rim and positive at the center. However, the magnetic field from the generator produces induction in conductive loops *when there is no relative movement.* The effect is seen . . . and used . . . in a U.F.O. detector put out by a club. This instrument, on being examined, was found to be a deflection magnetometer with a closed conductive loop. The presence of a craft is indicated by the deflection of the magnet from the N/S line. It seems, therefore, that the flux from the generator is continually expanding— which implies an indefinite, or infinite, quantity of energy!
4. "Perpetual Motion": Once the machine has passed a certain threshold of potential, the energy output *exceeds* the input. From then on, the energy output seems to be virtually limitless. The estimated power output of the generator is some 10^{13} or 10^{15} Watts, which puts the figure too high to be attributable to a solar source.
5. Inertia loss: Above threshold potential, which must be some 10^{13} volts, the generator and attached parts become *inertia free.* This, of course, jars very severely with accepted concepts of inertia in mass.
6. Drive: By altering the distribution of potential on the surface of the craft, it is possible to propel it. The preferred direction of travel at ultra-high speeds is away from the planet, the plane of the generator being at 90 degrees to the gravity field. When in horizontal flight the craft takes up an angle to the gravity field suggestive of the balance between like vector fields. The generator may produce a gravity field of its own.
7. Ionization of the air: This is a simple electrostatic effect. It gives rise to a translucent glow surrounding the craft and glowing trails. The intensity of the field is such that it is capable of excluding the ionized air, creating a *near vacuum* around the craft.

8. Permanent electric polarity: Searl noticed that after working near craft or generators he had a "cobweb" sensation on the skin. His clothes clung to him and also the bed linen. This was accompanied by occasional crackling and lasted some hours. This effect could be attributed to a permanent polarity of dielectric material, in this case the material being body tissue. Little work has been done on permanent dielectrics, but reference may be found in the records of the Physico-Mathematical Society of Japan, 1920. The work was carried out by Prof. Eguchi, Naval College, Tokyo.

9. Matter snatch during acceleration: This occurs when the craft is on the ground, and the drive is suddenly switched on. The rising craft takes up a lump of the ground with it, leaving the familiar tracks.

APPLICATION OF THEORY

The ultra-high potential produced by the Searl ring generator being that much greater than the ionization potential of the air, causes ionic breakdown of the air at some feet from the craft skin as this acts as the positive electrode. The negative side of the generator is connected to the periphery of the disc and is isolated from the skin. The field at the negative terminal loses electrons and the resulting ions are repelled away from the terminal with high acceleration. The electrons pass through the generator, constituting the current in the generator and provide the charge at the negative terminal to produce negative ions in the air near the rim. *The craft, therefore, is enveloped in a vacuum.*

In ordinary high voltage generators, maximum potential is limited by the ionized breakdown of the air. Flashover occurs and the accumulated energy is lost. The geometry and the arrangement of the field coils in the Searl generator is such that flashover is eliminated until the thing is in a vacuum and is then impossible. Energy is required to build up the potential and initially has to be supplied from an external source. As the vacuum layer increases about the craft, less energy is required to maintain the potential. The generator soon reaches a potential where the Searl Effect takes place, and the device produces its own energy along with the levitation phenomenon. On the basis of the theory, at this potential the stress on the space "fabric" cannot be equalized by flowing magnetism (current flow) through the air and craft as a circuit. The space fabric breaks down to provide the magnetism to relieve the stress, but the energy by-product is absorbed by the generator, which reinforces the field.

The generator then must set up an *ether flow or flux* along the lines of the electric field as is conventionally represented. The direction of ether flow

is, however, in at the positive and out at the negative. This is deduced from
the Schappeller theory. The type field and the net effect of the craft field
plus the earth's gravitational field gives rise to a condition where the *ether
density* below the craft is higher than that above it. The craft therefore is
strongly repelled away from the planet and to stop it from shooting off into
space the field of the craft must be intentionally perturbed or limited. In
the drive condition, the craft is shot out of the earth field like a wet orange-
pit from between the fingers. The acceleration is enormous, but since all
matter associated with the craft is linked with the field, no distortion of any
part, including passengers if any, occurs.

The limit to the speed is unknown, but since the craft has no inertia
there is possibly no limit as we know it. Conventionally it would be safe to
say, however, that the limit should be below the speed of light. Above this
speed too much is unknown to take any risk, but since the craft carries its
own space with it, in a sense the theory of relativity is inapplicable!
(Another way to say it is that the craft does not travel *through* space, but
past it!)

It can be seen that a neutral zone appears below the craft as well as the
neutral ring above,—when the levitation drive is on. If matter becomes lo-
cated in the Zone, then it is held there. In consequence, the Searl effect craft
so far made have left their mark on the countryside in the form of large neat
holes when they suddenly take off. *The chunk of earth is taken up with
it*

The Searl Generator runs at low speeds and is unlikely to fly apart by
centrifugal force. Apart from this, the side effect electromagnetic forces help
to keep it together. As with other gravity fields, the flux favors passage
through matter, and so the field within the craft may be tailored by appro-
priately distributing the mass in the craft. This is of particular convenience in
manned craft, where the comfort of the crew may be improved by making
the cabin field about ½ "G."

When travelling in free space, the external field of the craft would re-
semble that of the combined earth and craft, since it would be moving
relative to a (comparatively) stationary ether.

Collision between the craft and large objects in space is very unlikely,
except in direct line of flight—when such could be seen and the craft rapidly
turned. The field is such that the objects are diverted past the craft. If the
object qualifies as a planet or moon, having its own gravity, then the craft,
oriented by the interaction of fields, is strongly repelled anyway, unless
measures are taken to alter the field of the craft. Small objects such as
meteorites are pushed out by the combined electric and dynomagnetic fields.
An object entering such a powerful static field is at first attracted, then
ionized, and then strongly repelled. The dynomagnetic field induces a mag-

nostatic (ordinary magnetic) field in objects which will interact with the craft's magnetostatic field at considerable distances (miles), and repel it.

It should be pointed out that only a very small amount of space fabric (ether) passes through the craft and an even smaller amount is converted for energy. However, as previously mentioned, small changes in the ether lead to large physical effect.

Even in deep space, the craft has an electronic flow through the generator, which is continuous along the electric field outside the craft. Electrons are picked up, and some leave the rim at relativistic speeds. These do not contribute to the drive. So the craft also carries its own negative space charge. In the atmosphere, the electronic flow is much greater, and the generator current is much higher. The craft therefore functions a lot better and has greater flexibility in space. In air, the recombination of ions gives rise to a pink to blue glow around the craft, and in damp conditions the ions in the air can give rise to condensation.

The only hazard thus far observed is that, if the craft hovers too long near the ground, the soil becomes burnt, due to the electric currents in it, which build up heat. Also, the nervous system of animals is interfered with by ionizing discharge, if they happen to get too close.

Bibliography:

1. Electromagnetic Theory — Stratton
2. Principles of Quantum Mechanics — Hauston
3. My Philosophy — Oliver Lodge
4. Physics of the Primary State of Matter — Davson
5. The Dramatic Universe — J.G. Bennett
6. Congress of Radionics & Radiesthesia, 1950
7. Energy of the Orgone — Reich

Simplified Principle of *Ether—Vortex* in Operation

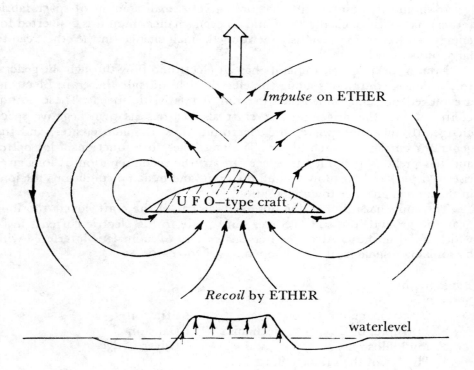

Impulse on ETHER

U F O—type craft

Recoil by ETHER

waterlevel

Observations by numerous reliable witnesses: Seawater peaked up toward the craft as shown.

Or: Snow was sucked up by low-flying craft overhead.

Or: Cars, trucks, and even a US helicopter in flight, were lifted up.

Or: Craft kicked up a small sandstorm in the desert.

Or: Chunks of soil are lifted up, treetops are spinning wildly, etc. etc.

Summary: The crafts observed obey Newton's third law of motion:
 "IMPULSE = RECOIL" (in the universal cosmic energy medium)

The Ether Flow Diagram of the rotating Searl generator, described by Mr. J.P. Roos on the following page as a double toroidal vortex, is somewhat more complex and therefore not shown here.

FEEDBACK CONCERNING THE BARRET REPORT

Mr. Jan P. Roos of Austin, Texas, a fluid dynamicist and president of the private "Association for Pushing Gravity Research," had this comment to make of the Barret Report:—"The theoretical explanation in the Barret Report, *based on the existence of an ether,* is quite correct. As a matter of fact, it parallels ideas I have on the subject. It is not difficult for a fluid dynamicist, as I am, to add the following to the report.

"The Searl generator creates a double toroidal vortex of ether flow, where the ether enters the axis of the double toroid at both sides, and emerges at the periphery of the circle where both toroids join. The wonderful aspect of toroidal flow is that it stabilizes itself such that its axis aligns with the direction of the surrounding flow. In other words-if the toroidal axis is at an angle to the direction of flow, a moment exists that tends to restore the angle to zero. Two such stable positions exist, 180 degrees apart. Hence the direction of flow, plus or minus, is of no importance. The joining of two toroids of opposite sign to form the above double toroid will not change this natural stability.

"If the gravitational ether flow is thought of as a flow of ether perpendicular to a flat earth surface, then the double ether toroidal vortex is stable when the ether flows in from below and from above, and emerges at the periphery of the horizontal circle joining the two vortices, as is demonstrated in the Barret Report. I think that this stability is very meaningful for this type of drive, and it certainly compares favorably with the special design problems required to maintain stability in helicopters, for example. Further, fluid dynamic theory states that, pertaining to forces in toroidal vortices, a toroidal fluid flow will not experience *any* force in a purely parallel fluid stream.

"Vertical flight control of a craft could therefore be done by varying the moment of one of the vortices; horizontal flight control could be ac

plished—as referred to in the Barret Report—by segmented toroidal flow, and by allowing a local toroidal section to increase in momentum (as presumably only the Searl generator is capable of)

"Congruent with the above formulation is the report that John Searl's first generator shot straight up into the air and disappeared, without arcing off into a horizontal direction! This is exactly what would be expected from the interaction of a symmetrical double vortex within a converging field. One could consider this all as a proof that the phenomenon of gravity is due to a converging (sink) flow of ether, as had been postulated by O.C. Hilgenberg back in 1931.*

"I myself can see that a cosmological ether theory leaves room for the Searl generator to be a reality. Only the non-material drive consisting of two super fluidic (non-viscous) ether vortices, excited and nursed to sufficient strength by a material drive, can explain John Searl's success."

We also have the published testimony of Dr. Arthur Cain, an American space expert, who travelled from California to England in order to examine Searl's claims:—"I was very skeptical indeed. In the meantime I have let myself be convinced that Searl's calculations are sound, and that he will make it." And further, Dr. Cain commented that "Searl's propulsion system will make customary propulsion as obsolete as a mill-wheel"

And More Feedback

Professor Shinichi Seiki, Uwajima City, Ehime Prefecture, Japan, developed a somewhat more elaborate theory of the Lorentz-Force, incorporating the use of the "ether." Starting with the so-called "Kramer-equation," which describes the movements of atoms in the presence of exterior electrical and magnetic fields—the basic components of the Lorentz-Force—Professor Seiki conceived of the possibility of creating "negative gravitational energies" by utilizing a suitable electro-magnetic field.

Currently, in a process called *NMR* (Nuclear Magnetic Resonance), we only utilize the changes in spatial electron spins due to the application of magnetic fields. The substance to be examined is placed in a high frequency field, and we observe energy absorption effects peculiar to the frequencies typical of a given molecule of matter.

Seiki went one step further and introduced *NER* (Nuclear Electrical Resonance), which influences *both* the polar *and* the axial spin. Polar spin, he claimed, is directly related to the gravitational field. Describing a rotating electrical AC field superimposed on a DC magnetic field, he claims that an

*"Über Gravitation, Tromben und Wellen in Bewegten Medien."

exponential increase of "negative gravitational energies" occurs at a certain resonance frequency. This means that energy from the earth-gravitational field enters the system of the secondary artificial field created by the anti-gravity motor. The negative G-energies cause a weakening of the earth-gravitational field, ultimately cancelling it altogether. Further depolarization then causes the vehicle to be repulsed by the larger gravitational body (earth).

It seems that the reason Prof. Seiki's NER effects have not yet been "officially" utilized, is that nuclear electrical resonance can occur *only* at extremely high electrical voltage *simultaneously with* ultra-high AC frequencies. Below this threshold, the probability of negative-G-energy conditions is extremely small. Above this critical frequency (also called—"Larmor Frequency"), the effect of this type of gravity engine is also dependant upon the electro-magnetic polarization potential of the materials used.

Professor Seiki proposes ferromagnetic substances, such as ferrit and ferromagnetic materials such as barium-strontium-titanate. In his design, three spherical condensers are alternately charged and discharged by three magnetic coils. At first glance, the entire idea seems to be just another "perpetuum mobile." However, the only energy transfomation used is that of gravitational energy into mechanical and electrical and vice versa.

Seiki calculated a power output of $3 . 10^9$ KW for an anti-gravity engine, using one ton each of ferrit and barium-strontium-titanate for the design. This is more than the total power output of a Saturn rocket, but, *even so,* Seiki's vehicle could carry a payload of about one ton!

Professor Seiki's work *does* seem to be taken seriously, as attested to by the fact that Dr. Wernher Von Braun considered it of sufficient interest to discuss it personally with him during one of Von Braun's trips to Japan.

And Still More Feedback:

Rotational Force Fields and Gravitation

From France comes a Dr. M.J.J. Pages, who postulates a "plenum"—substance analogous to the ether or cosmic energy medium—and describes a technique which could be defined as "lighter than spatial energy" (analogous to "lighter-than-air" craft.)

Published in "REVUE FRANÇAISE D'ASTRONAUTIQUE, No. 3, 1967," Dr. Pages considers it possible to imagine an entire astronautical technique with extraordinarily high performance; so high, in fact, that it *jeopardizes all of the physical and biophysical concepts presently considered as infallible dogma at most universities.*

After giving his definition of an electro-magnetic Magnus Effect, he declares: "To illustrate these mechanisms (of directive, degravitative, pro-

pulsive effects), I wish very specially to describe an experiment that I personally performed in 1921, and that I found later in a scientific magazine. By reason of the importance of this experiment, I believe that the full text of its description is in order. Here is the text. (Historic, French original).

Electrostatic Experiment of the Flying Disk

"We also saw in the Ducretet House an old apparatus that has been forgotten for a long time and which merits being returned to a place of honor. As can be seen, it is a mica disk which is mobile on a point and which assumes a very rapid revolving motion when it is presented to a very powerful static machine, such as the Wimshurst machine.

"The rotation is then so energetic that gravity appears to be eliminated by centrifugal force although the latter seems to give only horizontal components, and the disk *flies off*

"I saw the disk revolve, for the first time, in London a short while after the Coup d'Etat, when I was taking the Faraday courses. Some time after returning from exile, Ruhmkorff again showed me the experiment, and we discussed causes of the phenomenon that were not indicated by Faraday, but neither of us could arrive at an acceptable idea.

"This incident came to my mind twenty years later when I thought of using an iron disk which does not revolve at a lesser speed and which we place in motion in many different manners, as we shall explain at greater length on occasion. Then I discovered an explanation for the motion of the iron disk which I think is a proper explanation and which I hope to see accepted by official science. I shall wait and see if it does not happen to apply to the mica disk, "mutatis mutandis."

"The motion of the iron disk produced by electromagnetism has already been used in industry in the form that I conceived and by the processes that I indicated. More or less satisfactory modifications have permitted a considerably wider use, and we think that it is far from having said its last word in the great question of the transportation of force from a distance.

"Who is the inventor of the mica disk which to me seems a required complement of any respected electrical machine, at a time when it is such a question of revolving magnetic fields and direct rotations to which—by a series of strange circumstances—he indirectly gave birth? Mr. Ducretet, who built the model that we are presenting, informed me that Rumkorff claims to have invented it and that the invention claim was contested by Abbe Laborde; but the description published in "Les Mondes" (No. 23) goes back only to 1870, at a date much later than the experiment which I witnessed. There remains the question of the Faraday priority that I reserve."

"What is certain is that a similar disk is described under the name of

"Franklin tourniquet" on page 271 of the Sigaud-de-la-Fond treatise, but this disk is fitted with a band of tin which does not exist in the disk that we are discussing. Placed between the two balls of a Wimshurst or Holtz machine, the Franklin disk assumes a very great speed without the necessity of using points.

"This experiment, forgotten for more than a century, is obviously similar to the other two and served as their preface. This is not the only time that we can note that nothing is more fruitful than to compare with modern electricity the theories, the principles and the experiments of 18th century electricity—a forgotten science that we disdain and disregard too much today. With the meager means at their disposal, the 18th century electricians were absolutely marvelous!

"Since there is a constant strict analogy between the phenomena of the two electricities, and since after all the same forces are at work, an intelligent look thrown to the rear is often the most powerful manner of reading in the darkness of the future.

W. de Fonvielle"

At this point, the reader cannot disregard the fact that we have certain historical precedents to the Searl experiments with flying discs!

A compatriot of the French reporter above is John Carstoiu, Senior Research Scientist of the Atmospheric Sciences Research Center, State Univ. of New York, at Albany, and also of the Univ. of Paris, Dept. of Theoretical Mechanics, Paris, France. In a paper dealing with the unexplained inertial properties of spinning objects, and entitled "The Need for a Critical Reappraisal of Einstein's General Relativity," he states:

"There are a great number of gravitational phenomena on which Einstein's theory throws no light. For instance, it is very odd that neither Newton's Law or Einstein's Relativity can explain *the rotations of the planets*. Everybody takes the rotation of a planet for granted, but would the latter admit an explanation as planetary orbits do?"

He continues to press the issue by stating,—"The curved space-time universe of Einstein is a splendid object of mathematics, but what about its physical reality? . . . There is no experimental check to support the very heavy mathematical structure of purely mathematical extensions, complements or modifications of the original theory— *without any additional* experimental evidence."

In another paper,* dealing with the possibility of gravitational vortices, Carstoiu indicates that:—"A variety of cosmogony, in particular the rotations of planets, might be related to the existence of the gravitational

Gravitation and Electromegnetism—tentative synthesis and applications. (unpublished paper) John Carstoiu, The University of Paris Theoretical Mechanics, Paris, France.

vortex . . . as we see, the gravitational vortex opens large fields of investigation."

Bruce DePalma, an M.I.T. graduate and former appointed M.I.T. lecturer, is likewise concerned with rotational effects on gravitation—as well as with the blind ineptitude and unwillingness of the scientific establishment to investigate these matters,—"We have discovered that the spinning or rotation of objects *changes their inertia!*" He is able to prove experimentally that rapid spinning or rotation radically alters the physical properties of an object.

DePalma says that the experiment goes to the very heart of the nature of things; atoms, which are also rotating objects or force fields!

As rotation affects the physical properties of matter, it necessarily changes the very things upon which physicists have so fondly based their theories in the past. The effect goes against the grain of Einstein and Newton's theories of gravitation—which state, basically, that all objects, regardless of mass, fall at the same rate because of their inertia. (The tendency to remain at rest when at rest, and to remain in motion when in motion.)

The analogy between the kinematics of a spinning sphere and that of the electron in the gravitational field may cast some light on the mechanism of Searl's discs.

Again, according to Dr. Pages, when the *axis of spin of the electrons is merged with the radius of gyration,* we witness electromagnetic propulsion by *Magnus Effect:*—"The electromagnetic spatial vehicle—once it has degravitated from the ground by injection of the required energy for the necessary time—will be able to maintain this state of degravitation theoretically indefinitely . . . by creating a 'hole' in the cosmic energy (ether); such a hole would give an Archimedean effect."

And if we recall our History of Science, we will remember that it was Archimedes who discovered the "principle of buoyancy"!

One wonders what the picture will look like when all the pieces of the puzzle are properly placed relative to one another.

WHAT SOME SCIENTISTS THINK ABOUT IT

(Report of a Scientific Sub-Committee)

The functioning of the Levity Disc, depends entirely on the Searl Effect Generator. This is an electrical generator of unique design, capable of generating potentials above some 10^9 volts (thousand million) at relatively low speeds of rotation.

At a potential difficult to estimate, but of the order of 10^{10} to 10^{14} volts, the generator and attached metal parts become weightless. This fact is difficult to reconcile with current scientific theory and one might wonder why the phenomenon has not been discovered before. This is probably because potentials of this order of magnitude have never before been produced in the charging of large conducting bodies. It has been impossible because ionic breakdown of the air shorts out high voltage generators. The problem has been solved in the Searl design and the ionic discharge is used to create a vacuum around the generator. Thus the generator works in a perfect insulator, and the fields are so arranged as to limit the possibility of flashover. By "weightless" we mean free from gravitational force *and free from inertia*. Thus, although energy is required to maintain the electrostatic potential of the craft, little force or energy is required to propel the craft at tremendous speeds. Also, since inertia is absent, the laws of physics *no longer apply* and acceleration can be almost instantaneous without forces being felt on matter within the craft.

The claimed facts above conflict in concept with accepted theory, but it must be remembered that a theory exists to explain the Searl Effect, based on a space continuum which is *more than the absence of matter*. It is regarded as a fundamental substance from which all matter and energy is derived. This is not a new idea, but one which has not been developed as have other theories. (ETHER THEORY!) The second staggering property of the Searl generator is that when running above the "threshold potential" it produces energy from no known source, is self-perpetuating and continually pours out energy into the discharge corona surrounding the craft. It also

transmits energy in a magnetic field, not as electromagnetic radiation but as a *non-oscillatory field which continually expands.*

The disc shape of the craft is the obvious shape to contain the generator which is made up of concentric rotating discs and rings and the composite machine is tailored specifically for a space vehicle. For flight at high speeds in the atmosphere, the ratio of depth of the disc to its radius is a specific value. The comparison between the levity craft and the rocket is the comparison between an electric motor and a water wheel.

The rocket principle is relatively crude and has been developed very little since the German V-2. It certainly has been surrounded by some very clever ancillary equipment. But the fact still remains that the rocket is the end product of war effort and reflects the thinking of men of the Earth, not of the Universe.

The Searl craft can not be used to deliver bombs, since they can not be released from the field of the craft. Also, it is suspected that the energy precipitation quietly reduces unstable elements to a stable state and so nuclear bombs become useless. (The research on this is yet to be done.)

The craft's features most compatible with space travel are the possible high velocities, the anti-gravitational and the inertia-free properties. Occupants of such a levity disc are, as it were, in a world of their own, a "space" of their own! There should be no acceleration forces, no vibration, no feeling of movement; and to add to the comfort of the crew, the gravity flux generated by the craft can be partly directed through the cabin to give an acceptable weight to matter inside. The craft has no need to carry energy as fuel, since it creates energy from the medium it rides upon. Because of this, the planets of our solar system need not be the limit of its range. Since the craft is independent of the space medium and is inertia-free, it is not limited by the medium in its maximum attainable velocity.* In other words, it should be capable of speeds greater than that of light. However, this is venturing very much into the unknown, and more work will have to be done on the nature of the space-time continuum before risking such a speed with man-carrying craft.

It is the intent of the principals involved with the Searl Effect Generators to form a company, devoid—insofar as possible—of purely financial and governmental interests, so as to insure the fullest benefits of the invention to mankind as a whole.

*This statement is probably somewhat erroneous . . . a loose use of language. My understanding is that the craft is interdependent with the space fabric, "ether" or whatever we choose to call it, and until more is learned of the properties both of this "ether" and the functional interaction between the medium, the generator, and changing inertial forces, we would presume that there *is* some upper limit to velocity—although this may well be above the speed relationship which we now term the "speed of light," which is actually only relevant to our three-dimensional space/time concepts. (the editor)

R.K.

PROF. BURKHARD HEIM AND THE GERMANS

A human symbol of shattered Germany at the end of WW—II, Burkhard Heim had lost his eyes and his hands in a laboratory explosion. Besides that, he was left almost deaf. But his drive and his intuition were still very much intact. In spite of these seemingly insurmountable handicaps, he managed to graduate in theoretical physics (1954) and since 1956 he became heavily engaged in research pertaining to the nature of forcefields. In order to develop and test his new theories, a special "Research Institute for Forcefield-Physics" was established in 1958, associated with the University of Goettingen in Northeim, Hannover. As proclaimed on the letterhead of the Institute it also represents the "German Section of the European Center for Gravity Research."

As early as 1952, Heim had presented his first public lecture* in Stuttgart, revealing the discovery of a positive lead to anti-gravity, involving a "transitional field" which acts as an intermediary from electricity to gravity. Alas, when Prof. Heim disclosed his theory of "field propulsion" for space-flight at the Second International Congress for Astronautics in Innsbruck, Austria (1952), the history of science gave a repeat performance—Heim was ridiculed!

Considering that this occured quite a few years before SATURN moon rockets and MARINER landers had become household words, and astronautics as such was about as unpopular in scientific circles as serious UFO-research is today, perhaps this should not have been too surprising.

Stung by that experience, Heim swore to remain silent henceforth, until even the last iota of his new theory could be proven by exact laboratory data without the slightest remaining doubts. Since then, mysterious but generally poorly-informed references to his research have shown up in the European, North American and South American press, but officially, by and large, there was only discrete silence about his research results.

*"Die dynamische Kontrabarie als Losüng des astronautischen Problems," (lecture) Stuttgart, 1952

One of the first American observers to call attention to the work of Heim was Major Donald E. Keyhoe, the former director of NICAP*: "If Heim were right, the amazing properties commonly ascribed to the mysterious 'flying saucers' would be in fact, sound physics and proper engineering." The official silence surrounding Heim's research caused Major Keyhoe to conclude somewhat hastily:—"Heim's work toward the goal of an actual anti-gravity device using 'field inducers' has evidently been put under official German security. He has refused to divulge the key to his formula." He also gave an additional hint of Heim's difficulties when he declared:—"Heim's findings would indicate that anti-gravity researchers *may discover new scientific laws and that their work may invalidate old theories.* Some scientists are already saying privately that Einstein's famous 'General Theory of Relativity' may turn out to be totally fallacious."

Perhaps it is this last statement which comes closest to the real truth. Ever since this time, speculations abound—about the research results of Heim, (who is listed in the official "Who is Who").**

In any case, a personal letter written by him in January of 1976 explains (translated from the German)*** ". . . it is correct that I worked in the field of gravitational physics . . . it seems to me that a publication is certainly justified; however, it is questionable whether I, as a 'loner,' will be able to push through such a publication in the Federal Republic of Germany—in spite of the present 'science management.' I shall be happy to inform you if I should be able to achieve this goal." (signed) HEIM

At the time of this writing, the following facts are already known about his work:—He arrived at a "Unified quantum field theory of matter and gravitation" which has eluded Einstein during his lifetime. This field incorporates among other features:

a. The existence of a "gravitational vortex" phenomenon.

b. A propulsion method through "effective acceleration fields" based on what Heim terms the KONTRABARIC EFFECT.

c. The emission of gravitational waves with resultant electromagnetic radiation fields and induction of strong magnetic and electrical fields.

d. The apparatus which can achieve the transformation of E/M energies into gravitational forcefields will have to be large-surfaced (as-for instance—a disc-shape).

In short, Heim's theory predicts all the effects which have been observed in connection with UFO sightings for decades.

*"*I Know the Secret of the Flying Saucers*" by Major Donald E. Keyhoe, USMC (Ret.) TRUE Magazine, Jan. 1965. USA

**"Wer ist Wer" Das Deutsche Who is Who, XIV edition, ARAMI Verlags GMBH Berlin-Gruneweld

***(private communication)

In the opinion of a German physicist who claims to be familiar with Heim's work, it represents (quote)—"The only consistent formula for the mass of elementary particles and resonances as well as their lifetimes, whose values are given exactly . . . Heim's theory makes it possible to test in the laboratory new results concerning *reciprocal action between electromagnetic and gravitational fields*. The CONTRABARIC EFFECT should make possible the production of gravity waves."

It is claimed that Heim's theory can provide the extraterrestrial hypothesis (ETH) of many UFO's with a sound theoretical basis. Latest available information would indicate the official publication about his research to be already in preparation.

German Research: Hypothetical configuration of a secondary gravitational field.

FRANCE: "THE GRAVITATIONAL FORCE CAN BE NEUTRALIZED"

Dr. Marcel Pages, doctor of nuclear engineering and medicine, born in Perpignon, France, is a founder and member of C.I.R.G., an international research center on gravitation created in Rome, Italy, in 1961. He determined the characteristics of an experimental prototype of a true spaceship and received a patent (No. 1, 251.902) for such a vehicle, which is described and reproduced in his book "Le Defi De L'Antigravitation" (The Challenge of Antigravitation; published by Editions Chiron, Paris, 1974).

A strong proponent of a universal cosmic energy medium (the "ETHER"), Dr. Pages explains that objects are not attracted by internal terrestrial forces of this or other planets, but rather held down by a force of cosmic space. The apparent end result is the same and does not contradict Newton's law. His basic principle of antigravitation is remarkably similar to that of other scientists defending the existence of the ether. "In only a few months I could give France the number one position in the space race . . . that would leave cyclopic American or Russian rockets of classical conception far behind. Applying the antigravitation principle, this spacecraft could rush into interstellar space faster than light," explains Dr. Pages." A body falls towards Earth or ricochets back towards the cosmos accordingly as its density is greater or less than that of the environment in which it ingresses." He lists the examples of cork in water or a hydrogen balloon in the atmosphere. Consequently, this cosmic (ether) energy must create around a planet a particular energetic atmosphere analoque to the planets gaseous atmosphere, with a few fundamental differences. A priori, its mean density must be inferior to that of matter since the material body falls into it. On the other hand, if it could be possible to determine an energetic climate of lesser density than the ambient environment of our atmosphere, there would occur the manifestation of an ascending repulsion. Dr. Pages explains: "We must notice the complete analogy between the Archimedian reaction of an airless balloon in the atmosphere which is crushed by atmospheric pressures

93

of many thousands of tons of which the ascending force is only due to the weight differences of displaced air, and the Archimedian reaction between two hemispheres charged positively and negatively that are crushed by colossal forces, but of which the elevating force is solely due to the difference between the mathematical mass of the energy that has been transformed by manipulative interference inside the balloon and that of the ambient energy. *The gravitational force can be neutralized by producing an inversed field of electromagnetic nature.* Any engine or rocket capable of producing such a field will escape gravity and limitlessly actuate itself, guided simply by field orientation."

Dr. Pages' design of a space vehicle of this type is explained in his book by the following principles:

Weight cancellation is possible by causing a charge of electrons, extracted from the body to be degravitated, to rotate around that degravitated body. Such a degravitation is, theoretically, accompanied by the neutralization of the effective mass—thus the inertia of the whole system. In consequence, a minimal acceleration in this state provokes phenomenal speeds. Based on this premise, a machine of such a type will have its external appearance in perfect conformity with the shape of the well-known "flying saucer": a central sphere encircled by two inversed discs.

Within the central metallic sphere, the pilot's cabin would be situated. Charged plates would ornament the exterior of the isolated disks on the top and underside, being connected to an *ultra-high frequency generator*. Dr. Pages' conclusion is stated thus: "It is therefore possible to be ejected out to the cosmos at theoretically unlimited speeds."* * One chapter of his book is devoted to a critique of relativity, and a quote from the reputable French magazine "Science & Vie" reproduced in Dr. Pages' book seems worth repeating as a tribute to gallic pride:

"In this particular domain (of antigravity research), the French physicists are several years ahead of their foreign colleagues." (Sept. 1967, No. 600, p. 54).

This claim is perhaps fairly close to the facts.

Another team of three top French scientists have been reported to be on the verge of solving the propulsion mysteries of UFO's, among them Prof. Claude Poher, director at the National Center for Space Studies, the French equivalent of NASA.

Having investigated about 35,000 UFO sightings by computer analysis, Dr. Poher has stated in public that "UFO's really exist!"

A small model of their UFO—propulsion unit, about one m² in size,

*"*Le Defi De L'Antigravitation*" Editions Chiron, Paris, 1974, by Marcel Pages (no English edition available)
**"*Cosmos Express*" P.O. Box 3, Jonquiere, Quebec, Canada

reportedly utilizes electromagnetic and nuclear energy. "Our engine captures and harnesses that energy to provide tremendous thrust," claims Dr. Jean Pierre Petit, a plasma physicist at the French Government's National Organization for Scientific Research. This so-called "Petit-Viton" engine uses both an E/M field and a magnetic field and is supposed to be capable of moving a spacecraft model at a simulated speed of three times the speed of sound *without* producing a sonic boom.

"All the elements are already available—it's simply a question of putting them in order," states Dr. Petit*. On the aspect of UFO reality in general, Jean Claude Bourret, chief editor of the TF1 (the first French TV program) replied to a reporter for the publication "La Suisse" (June 26, 1976) in response to his question of how many UFO—sightings have been confirmed all over the world: "About 90 millions during the last 40 years!"

Whatever the case might be, the conclusion of James M. McCampbell, Director of Research of MUFON, USA, is very much to the point: "The French are moving out!"**

Addendum

Perhaps one of the most remarkable contributions was made by the French Minister of Defense, M. Robert Galley, in an official interview broadcast on the French radio program "France-Inter," in 1974.

During this particular interview with Jean-Claude Bourret, the high French official freely admitted that:

1. UFO's exist,
2. They are a serious problem,
3. Many landings have taken and are taking place,
4. The French Ministry of Defense has secretly studied the problem since 1954, and
5. Has forwarded all reported UFO-material to French scientists for evaluation.

*"National Enquirer" Nov. 2, 1976, p. 4 "Team of Top Scientists Say They've Found the Secret of How UFO's Fly." (USA);
**private communication from James M. McCampbell, dated 2-14-1977.;

INPUTS FROM OTHER SPHERES OF CONSCIOUSNESS

INPUTS FROM OTHER SPHERES OF CONSCIOUSNESS

"When science turns toward spiritual discoveries, it will make more progress in 50 years than in all its past history."

(Charles Steinmetz, 1865-1923)

More and more of the "top" men in science begin to lean towards spiritual factors, as demonstrated by Professor Kistemaker in Holland who combined the function of Director of the Atomic Laboratory with that of President of the Dutch Society for Psychical Research. It certainly was no accident that Einstein was interested in extrasensory perception; nor that Nobel Prize physicist Professor Max Planck stated, "The finding of the truth can *only* be secured by a determined step into the realm of metaphysics."

As an interesting intellectual experiment, let us follow Max Planck's suggestion with an attempt to analyze the existing "metaphysical" information on the legendary sunken continent Atlantis in reference to electromagnetic field propulsion for aerial vehicles.

The term "metaphysika" derives from the Greek and can be best interpreted as "beyond physics." Information from sources which are generally considered scientifically unacceptable will, of course, not convince a skeptical person and this attempt should not be construed as anything even faintly approaching the claim of "scientific proof."

However, it is presented here because of the truly amazing, inherent redundancy in all of the following statements stemming from psychic sources, and in order to prepare our thinking habits for the existence and use of potential corroborating information—sources of very considerable importance.

The first known, historically documented account of the legendary sunken continent Atlantis can be found in Plato's writings, which describ a

99

Edgar Cayce — 1943

conversation between Solon of Athens and some Egyptian priests, and dates back to the seventh century B.C. Since then, more than 22,000 books and novels have been written on this subject in countries all over the world; among the better known authors are Pliny of Rome and Francis Bacon with his "The New Atlantis." Because legends of a great global flood or cataclysmic deluge can be found among all known ancient races and religions of the world, it would appear difficult to defend the hypotheses that all these many volumes should have been written without the slightest foundation.

In 1895, Scott Elliot published a book titled *The Story of Atlantis*, describing the aerial vehicles of that legendary continent which he called Vimanas as "seamless and perfectly smooth, and they shone in the dark as if covered with luminous paint." This description bears a remarkable resemblance to some of our present-day UFO reports, indicating a glowing, ionized "field of force" in many night-time sightings; yet it appeared half a century *before* the public began to even take note of the UFO problem.

America's best known prophet is no doubt the much publicized Edgar Cayce, who left a legacy of more than 14,000 psychically obtained readings. If we check the Cayce records in an attempt to locate information on Atlantis, we will find numerous detailed "readings" on this subject, together with highly significant statements about technological achievements of that mysterious civilization of a long by-gone age.

For the die-hard skeptics, it seems appropriate to note that Edgar Cayce's readings on the subject of Atlantis were given over a period of twenty-three years until the time of his death in 1945, during a time span which was as much unaware of the abbreviated term UFO or "unidentified flying object," as of the technical terms "electro-gravitation" or "force field-propulsion" of much more recent vintage. None of these were in existence at the time of Edgar Cayce's death in 1945. All readings were documented in the presence of witnesses.

Without quoting verbatim, and merely given as a brief summary of the indicated technology of that sunken continent Atlantis, these "readings" indicate that aerial vehicles were not unfamiliar at that time period, and dynamos and generators as well as some kind of gravity-control were apparently known. It is further stated that the aircraft of that time could travel equally well in the air, or on the water, or under the water—similar to the reported maneuvers of UFOs—and that *electrical forces* were used for the propulsion of these Atlantean "aero-electric aeroforms," as Edgar Cayce termed them. In view of the present day empirical facts on electro-gravitation as compiled and presented in this book, these particular Cayce readings appear indeed of tremendous importance!

If we leave Edgar Cayce and the dim past of Atlantis behind and turn to the future, we will find several completely independent statements of

persons with well-known psychic abilities, concerning the discovery of a totally new propulsion energy for air and space vehicles of the near future.

We might start with Käthe Niessen, a popular clairvoyant in West Germany, who says about imminent developments in the field of space travel: "A great scientific revolution will bring the discovery of a so far totally unknown energy source, *atomic-magnetism* (!), which will become of utmost importance for space-flight."*

Jeanne Dixon, the world reknowned clairvoyant from Washington, D.C. writes in her book *My Life and Prophecies* (1969) in chapter titled "On the Threshold of the Future"**: ". . . A major breakthrough in the field of propulsion, using magnetic and cosmic forces, will enable us to travel to far-off planets with a simplicity never before thought possible." Alas, this prediction of hers is closely coupled with the warning, "Our country is in more grave danger now than at any other time in our history. Much of the danger comes from within, created by our quest for materialistic goals and our apathy to danger."

One clairvoyant, who is best known in the South of the U.S.A., is quoted in a book titled, *The Man Who Sees Tomorrow* (1970) as having made the following prediction in reference to E/M Gravity Motors:*** ". . . A laboratory near . . . is approaching a breakthrough on an electro-magnetic form of propulsion. This topsecret device will enable vehicles to overcome gravity. The entire universe will be opened for exploration. However, it will be a number of years before E/M propulsion will be used." That particular psychic, "Doc" Anderson from Georgia, sees airliners powered by E/M engines and cars and trucks propelled by this new scientific discovery. In reference to this coming invention, he gives the following information, "A revolutionary new aircraft engine will be manufactured in Georgia . . ., it will be absolutely silent in operation. This totally new engine will allow supersonic flight by giant airliners and eliminate the shattering sonic boom." (the reader is urged to compare this forecast with the technical information in the preceding pages).

"Still later, the Georgia aircraft industry will flourish when a small, low-cost aircraft is built, powered by an antigravity engine. This will bring the cost of flying down to the average man."

Another American seer predicts the invention of silent aircraft in Germany "within the next ten years," by 1979. He describes this invention as the biggest technical breakthrough of the near future.****

*Das Neue Zeitalter, No. 14. April 3, 1971, (W. Germany) Internationale Weltvorschau für 1972, by Käthe Niessen.
**My Life and Prophecies, by Rene Noorbergen, 1969, William Morrow & Comp., Inc., N.Y.
***The Man Who Sees Tomorrow, by Robert E. Smith, Sept. 1970, Coronet Communications, Inc., 315 Park Ave. S., New York, N.Y. 10010.
****Criswell Predicts Your Next Ten Years, 1971, Grosset & Dunlap Publishers, New York

Paul Solomon

Finally, a fairly new psychic with enormous potential, Paul Solomon (pseudonym) called the "Second Edgar Cayce" by some, and living now in Virginia Beach like Edgar Cayce before him, confirms these statements in a "reading" given on 5-30-73. Although his phenomenal ability was only discovered in 1972, a selection of his readings was published as early as 1974.*

We are quoting from this publication the following statement in trance, given in reply to the question asked by the conductor:

"Is there anything, such as inventions or discoveries which we should be aware of that would help in the transformation from the old age to the new?"

Answer (in trance): "... was the question asked for the thrill or entertainment, or that you might be uplifted in this type of thing?

But if for spiritual growth, then it may be given that in your lifetime... there shall be discovered those instruments that shall be put to use for the purpose of floating metal or steel or even rock or stone through the air even as now such are floated through the water. This nuclear energy," (as will be explained in the following issues by the new definition for gravity's cause seen in the nucleus of the atom! Author) *"will be used in such a way that it would balance those pressures that would close in about an article, that would equalize that pressure coming from above the earth with that pressure that would push from below the earth, then causing these to sustain themselves above the earth, floating through the air. Then, these would be combined with thrust that would move through the air. In such a way were the pyramids formed; in such a way may such stones, such heavy objects be moved even in this day in this time...."*

These examples make it quite evident that proven psychic sources, utilized as an auxiliary tool for science, might conceivably be able to pinpoint tendencies for new developments and might very well be in a position to confirm empirical facts, to be translated into useable hardware in the near future.

Time will tell whether the psychically gifted persons quoted in this connection really had the genuine ability to correctly foresee and describe technical developments still shrouded behind the veil of the future.

*EXCERPTS from the Paul Solomon Tapes, 1974, Heritage Publications, Box 444, Virginia Beach, Virginia.

CONCLUSIONS

The various documented experiments and test results described in this book, from the United States and countries in Europe, point to identical and characteristic attributes of the ether as a universal cosmic pre-atomic force.

They are in unique agreement with a basic statement on the subject from another sphere of consciousness, a statement given by Edgar Cayce in a trance reading as early as 1931:

> Each atomic force of a physical body is made up of its units of positive and negative forces, that brings it into a *material* plane. These are *of the ether* [emphasis by the author], or atomic forces, being electrical in nature as they enter into a material basis, or become *matter* in its ability to take on or throw off.
>
> 281-3

This fully confirms another trance statement, made previously (in 1930) by Cayce:

> (Q-11) . . . *"A mechanical device might be constructed where a* vacuum even excluding ether *could be drawn and maintained, developing therby a levitating force; this similar to that force which exerts pressure upward when air is pumped into a steel barrel while submerged below surface of a medium such as water. This levitating force will be utilized in many ways, particularly in so-called heavier-than-air ships, with the result that air navigation will be possible* without the use of wings *or gas." Is this correct?*
>
> A-11. This correct when the elements must be made so condensed in their form *as to prevent the ether in its finer sense from being, or escaping through the various elements* that are ordinarily used for creating of such vacuums . . . a container in which a vacuum may be made must be of such a CONDENSED element as to prevent *ether from going through the atomic forces of the element itself,* as is seen in that of an electric bulb—this is NOT a vacuum, only a portion!
>
> 195-70

The reading refers here to the partial vacuum of an electric light bulb, *which still contains the ether*! [The author]

This truly astounding reading was concluded with the statement:

"Then the vacuum may'be made that would lift without being lifted, see?"

In the face of our professed frantic search for new energy sources and new modes of more efficient, energy saving transportation, the question arises then why the experiments listed in this volume, as well as the Edgar Cayce readings on the same subject, have been almost completely ignored for such a long time.

Perhaps the answer to this can be furnished by still another reading of the amazing Edgar Cayce, given in reply to the question of another seeker a few years later, who was already on the right track, so to speak:

Q-13: "Give the method of construction of an aircraft controlled by (a) positive electricity."

<div align="right">No. 412-9, 8/10/37</div>

Cayce's reply in trance admonished the man:

A-12: "It is a long way to these—and there must be determined *for what purpose* these are used before ye may be given how, in what manner. For these take hold upon *Creative Forces.* Show thyself approved, first!"

The reading was then abruptly cut off with the words (in trance):

A-13: "We are through for the present."

We are faced with the fact that an outline of an entirely new, revolutionary method of propulsion is now evolving. Like fans generally, the prop- or jet-engines of present-day aircraft move the air of our atmosphere purely *mechanically*; the ether as the universal matrix of all elements, including of course the chemical elements which make up our atmosphere, can evidently be moved *electrically*, taking the surrounding air or the craft itself along for the ride.

Cayce described the ether as the equivalent of the *Creative Forces.*

Interestingly enough, a confirmation is offered in a new British book by Dr. Dennis Milner and Edward Smart of Birmingham University, England: Their work pertains to the ether and "etheric-force-fields," and the book is labeled as a study of the purpose and the forces that weave the pattern of existence, bearing the title: *"The Loom of Creation".**

The most advanced scientific techniques are now applied to study the most ancient ideas!

Alas, it seems that Dr. Mitchell has indeed made the dilemma of our times quite clear when he stressed the universal need for a change of consciousness. If such a change should not occur, if the greed of vested interests, the intellectual prostitution of some members of the scientific community and the fraudulent practices of some segments of our business community should prevail in order to prevent the newly emerging ether-technology from developing further, it will be due to the fact that the collective attitudes of consciousness are still not yet ready for the "tapping of the ether," for working *with* the "Creative Forces" of GOD's creation, instead in opposition to them.

Whatever the case may be, we can be assured that the accomplishment of gravitycontrol and the mastery of new energies will never be achieved by mathematical acrobatics alone;

The admonition of the late Edgar Cayce in trance was clear and very much to the point. And it was directed to all of us, without exception:

"Show Thyself Approved, First!"

* Dennis Milner and Edward Smart, "The Loom of Creation," 1976 Neville Spearman Ltd. 112 Whitfield Street, London W1P 6DP

Is this the state of today's science?

"In the sub-micro world of quantum physics, perpetual motion as to spin and orbital motion *is required.*

In the macro world, however, science is based upon exactly the opposite — perpetual motion *is impossible."*

(John W. Ecklin,
Alexandria, Va. 22304)

MISSION IMPOSSIBLE?

Since the original material was published in 1977, the reader will be interested in the following update to the "Ether-Vortex Turbine" of Mr. J.R.R. Searl in England in the form of a letter received by Searl's close associate in New Zealand:

11 Dec. 1984

"I have received recently some information re: J.R.R. Searl which I think will be of interest to you.

In May 1982, on some sort of purported right of entry, some sort of Government inspectors or law enforcement agency invaded Searl's home, then at 17 St. Stephen's Close, Mortimer, Berkshire, England, and allegedly confiscated a "domestic type free-energy generator" he had installed there and which was under test, apparently supplying his own household with free electricity. Searl was allegedly prosecuted by the Southern Electricity Board on trumped-up charges of "stealing electricity by means of a unique device," the only real evidence being a sequence of unusually low metered electric bills, and he was sued for a very large sum of money. Searl was rightfully enraged when "they" would not return his "generator", and he refused to pay because of his treatment and the state of the home after "they" had torn out all the electrical wiring of the house and left it in shambles.

It does not appear, though, that Searl or his landlord sued "them" in turn for robbery and criminal damage, apparently because of legal advice they received. A minister of religion had to visit his home to rig up makeshift lighting and heating for his distraught family.

As the result of this, Mr. Searl's family allegedly broke up, he became very depressed, and felt it was the "end of everything" and tried to take his own life.

The Court allegedly decided to "put him away for a short period to quieten down" — actually "they" contrived to detain him for about a year.

While so detained, an arsonist set his house on fire, and most of his records and equipment were destroyed.

After his release from detention, in September 1983, he (lives) under an assumed name. . . He is allegedly receiving help from "unknown scientists". . . .

Extra-Terrestrial Archaeology

DAVID HATCHER CHILDRESS

With hundreds of photos and illustrations, *Extra-Terrestrial Archaeology* takes the reader to the strange and fascinating worlds of Mars, the Moon, Mercury, Venus, Saturn, and other planets for a look at the alien structures that appear there. This book is nonfiction!

Whether skeptic or believer, this book allows you to view for yourself the amazing pyramids, domes, spaceports, obelisks, and other anomalies that are profiled in photograph after photograph. Using official NASA and Soviet photos, as well as other photos taken via telescope, this book seeks to prove that many of the planets (and moons) of our solar system are in some way inhabited by intelligent life. The book includes many blow-ups of NASA photos and detailed diagrams of structures—particularly on the Moon.

224 pages
8¹/₂x11
Bibliography, Index,
 Appendix

$18.95/paper

Men and Gods in Mongolia

The Third Book in Our Mystic Traveller Series
HENNING HASLUND

358 pages
6x9
Travel/Adventure/Eastern
 Mysticism
Illustrated, 57 photos,
 illustrations and maps,
 all b&w
ISBN 0-932813-15-1
$15.95/paperback

This third book in our reprint series was first published in 1935 by Kegan Paul of London. It is a rare and unusual travel book that takes us into the virtually unknown world of Mongolia, a country that only now, after seventy years, is finally opening up to the west. **Haslund**, a Swedish explorer, takes us to the lost city of Karakota in the Gobi desert. We meet the Bodgo Gegen, a God-king in Mongolia similar to the Dalai Lama of Tibet. We meet Dambin Jansang, the dreaded warlord of the "Black Gobi." There is even material in this incredible book on the Hi-mori, an "airhorse" that flies through the air (similar to a Vimana) and carries with it the sacred stone of Chintamani.

Henning Haslund was a Swedish Explorer who accompanied Sven Hedin and other explorers into Mongolia and Central Asia in the 1920s and 30s. He is also the author of the book *Tents in Mongolia*.

NEW BOOKS

NIKOLA TESLA'S EARTHQUAKE MACHINE

with Tesla's Original Patents
Dale Pond and Walter Baumgartner

Now, for the first time the secrets of Nikola Tesla's Earthquake Machine are available, and now with new blueprints to build your own working model. Although this book discusses in detail Nikola Tesla's 1894 "Earthquake Oscillator" this book is also about the new technology of sonic vibrations which produce a resonance effect that can be used to cause earthquakes. Discussed in this large format book are Tesla Oscillators, vibration physics, Amplitude Modulated Additive Synthesis, Tele-Geo-dynamics, Solar Heat Pump apparatus, vortex tube coolers, the Serogodsky Motor, more. Plenty of technical diagrams. Be the first on your block to have a Tesla Earthquake Machine!
175 pages, 9x11 paperback. Photos, Illustrations & Diagrams. Bibliography & Index. $16.95. code: TEM

INTERNATIONAL TESLA SYMPOSIUM PROCEEDINGSS 1992

edited by Steve Elswick

The latest in high tech information on Tesla Technology, anti-gravity, free-energy and beam weaponry. Articles on Tesla Coils, The Black Hole Antenna, Electrostatics: A Key to "Free Energy", The Laser Cel, Moray B. King on the Progress in Zero Point Energy Research, Tesla's Particle Beam Technology, more. 18 all new articles in all in a durable hardback format. Heavily Illustrated.
200 pages, 9x11 hardback. Illustrated. Footnotes & Bibliography. $49.95. code: ITS92

SEDONA—SACRED EARTH

Nicholas R. Mann

A nicely illustrated book that demonstrates how the red rock area of Sedona in Northern Arizona is has geometrical and animal figures in its landscape that correspond with Native American myths and legends. This book draws on the concepts of geomancy, earth gird and earth chakra concepts to interpret the Sedona area in a similar manner as Glastonbury, England.
101 pages, 10x8 paperback. Photographs and maps. Bibliography & Index. $10.95. code: SSE

THE HISTORY OF AMERICAN CONSTITUTIONAL OR COMMON LAW

with Commentary Concerning Equity and Merchant Law
Dale Pond, Howard Fisher, Richard Knutson & the North American Freedom Council
Possibly the best selling Common Law book in existence, this short and easily read book tells it the way it is. We can see the deterioration of the democratic process in America and the misuse of power over many by a few. This no-

nonsense history is also a guide to show how "we the people" can restore ourselves as Masters of Congress and our Country where we instruct our government employees what to do instead of taking orders from them. "If Americans knew what was in this book, the country would be free overnight," says one of the cover blurbs. Includes 16 sample court arguments and briefs including Rights of a Freeman, Common Law vs Civil Law Rights, Corpus Delicti, Federal Citizen or Sovereign Citizen?, more.
142 pages, 9x11 paperback. Illustrated with Index. $11.95. code: HCL

ENERGY-EFFICIENT MOTOR SYSTEMS

A Handbook on Technology,
Program and Policy Opportunities

From the American Council for an Energy Efficient Economy. An indispensable basic handbook on electro-magnetic motors and how to build or design your own. Chapters in this thick reference book are on Types of Induction Motors, Motor Efficiency, Motor Rewinding, Motor Testing Standards, Harmonics and Transients, Distributions Network Losses, Saturation of High-Efficiency Motors, Load Factor, Variable Speed Motors, Oversized Wiring as a conservation measure, more. Tons of info, including an appendix of motor manufacturers and suppliers.
379 pages, 6x9 paperback. Illustrated with diagrams, photos and maps. Appendix & Document Section. $25.00. code: EEMS

Please use item codes when ordering http://www.azstarnet.com/~aup

NEW BOOKS

DISNEYLAND OF THE GODS
by John Keel

Are we being invaded from outerspace as many UFO hobbyists contend? Are secret government agencies tapping your phone and tampering with your mail? Does somebody else really own this earth and use it as a Disneyland of the Gods? Veteran Fortean author Keel reports with wit on the startling encounters with "the tricksters" (so well-known to the American Indians), the Men In Black, assorted monsters, snallygasters, mothmen and weird hairy creatures that all seem to vanish into thin air. Chapters on UFO crashes in Scandinavia, Mysterious Crime Waves, Clones, Hybrids and Sleepers, An Idaho Triangle?, Sea Monsters, The Moonstone Mystery, New Age of the Gods, more.
175 pages, 6x9 paperback. $9.95. code: DOG

SCIENCE FRONTIERS
Some Anomalies and Curiosities of Nature
compiled by William Corliss

This large format paperback book is a massive compilation of the curious Science Frontiers newsletters published by Corliss' Sourcebook Project of anomalies in science. Chapters in this book are on a wide spectrum of information from Ancient Engineering Works, Strange and anomalous ancient bones, footprints and writings, geological anomalies, strange weather and atmospheric phenomena, astronomical oddities such as solar system debris, planets and moons, plus chapters on odd-ball biology stuff such as genetics, evolution, human anomalies and much more. Also chapters on hallucinations, reincarnation, psychokinesis, mathematics and Esoterica.
352 pages, 8x11 paperback. Heavily Illustrated. $20.00. code: SCF

MICHIGAN PREHISTORY MYSTERIES
by Betty Sauders

The lost world of ancient Michigan is explored in Betty Sauders two books about ancient mounds, Hittite tablets, copper miners and more around the Great Lakes. This book explores the mystery of the Copper people who were mining the virtually pure copper on Isle Royale of Lake Superior more than 5,000 years ago. Well illustrated with chapters on the Newberry Stone with its ancient Hittite inscriptions, the pyramids of Michigan, rock inscriptions, more.
261 pages, 6x9 paperback, Illustrated. $14.95 code:MPM

MICHIGAN PREHISTORY MYSTERIES II
by Betty Sauders

Betty Sauder's second book on the mystery of the Copper people who were mining at Isle Royale of Lake Superior more than 5,000 years ago. This book contains chapters on Egyptian and Norse visitors to the Michigan area, the famous Michigan copper plates, giant stone heads, the Mongolian connection, petroglyphs, rock maps, more on the Newberry Stone with its ancient Hittite inscriptions, Indian legends, more.
261 pages, 6x9 paperback, Illustrated. $12.95 code:MPM2

THE WHISTLER SERENADE
Stonehenge Viewpoint Series
by James S. Brett

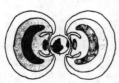

This large format book is more on strange phenomena of whistlers and other unusual atmospheric phenomena such as earth lights, ball lightning and anomalous lights. Particularly interesting in this book is a detailed study of the Marfa Lights, the mysterious lights that appear nightly on a remote mountain in southern Texas. Other odd-ball material is collected here such as a convention at Giant Rock, California, waiting for the "Space Brothers" and their Whistler Friends, Van Allen Belt Discharges, the Earth's magnetic field and whistler phenomenon. This book is companion volume for Crop Circle Secrets and America's First Crop Circle. 96 pp.
9x11 paperback. Illustrated with photos, diagrams & charts. References & Resources. Index. $12.00. code: TWS

24 hour credit card orders – call: 815 253 6390 ▪ fax: 815 253 6300 ▪ Email: aup@azstarnet.com

NEW BOOKS

PSYCHIC DICTATORSHIP IN THE USA
by Alex Constantine

Bombing minds rather than bodies the warfare of the new millennium. Alex Constantine's explosive book uncovers the terrifying extent of electromagnetic and biotelemetric mind control experimentation on involuntary human subjects in America today. Funded under the euphemism of "Non-Lethal Technology," the Pentagon has developed the ability to transmit voices, and inflict pain, madness, even death, at the push of a button. This book investigates the use of cults by intelligence operatives for arms sales, mind control and even child abuse to create assassins with multiple personality syndrome. Also covered, the role of the artificial Nutrasweet in "mind control" experiments, False Memory, mind control and UFO encounters, the technology involved, more.

221 pages, 6x9 paperback, Illustrated with photos & newsclippings. $12.95 code:PSU

SECRET AND SUPPRESSED
Banned Ideas & Hidden History
edited by Jim Keith

Veteran conspiracy researcher Jim Keith takes us into the bizarre and dark world of conspiracies to control the world and suppress history. Chapters on Jonestown in Guyana as a CIA mind control effort, the "invitation to war" to Saddam Hussein, silent weapons for quiet wars, Danny Casolaro's "Octopus" manuscript, Why Waco?, AIDS: An Act of the Pentagon, Secrets From the Vatican Library, Brain Implants, exposing Nazi International, more.

309 pages, 6x9 paperback. Illustrated. $12.95. code: SSUP

THE ATLANTIS RESEARCHES
The Earth's Rotation in Mythology & Prehistory
by Paul Dunbavin

This import from Britain is an impressive compendium on Atlantis, pole shifts, Flood myths and legends, ancient geological catastrophes, and sunken lands in the vicinity of the British Isles. Well illustrated with chapters on The Chandler Wobble, Memories of the Flood, The Calendar Confusion, Beneath the Irish Sea, Druids and Standing Stones, more. 17 chapters in all.

304 pages, 6x9 paperback. Illustrated. $22.95. code: TAR

FOREIGN AGENT 4221
The Lockerbie Cover-Up
William C. Chasey

According to Foreign Agent William Chasey, there is a cover-up occurring over the Lockerbie disaster that makes "Watergate, Irangate and Whitewater pale by comparison." According to Chasey, who was sent by the State Department to Libya, the United States, Great Britain and Scotland have conspired to keep the real perpetrators from being exposed while they falsely accuse Libya. Chasey discloses information that was previously covered-up and names the real parties responsible.

372 pages, 6x9 tradepaper. Illustrated with photos. Index. $17.95. code: FA4

DISAVOW
A CIA Saga of Betrayal
by Rodney Stich and T. Conan Russell

Defrauding America author Rodney Stich brings us this twisted tale of CIA money laundering, the CIA's Australian Nugan Hand Bank and its various officers (some of them murdered), This book reads like an exciting detective story but is actually a highly detailed and documented book revealing the innermost secrets of a large CIA operation headquartered in Hawaii, how deep-cover CIA functions are funded, how these covert operations are sometimes exposed, how plausible denial works and how CIA officials avoid responsibility for their acts while shifting the blame to innocent parties. "A fantastic story," said Peter Jennings on ABC World News Tonight. For all those interested in recent banking controversies such as the BCCI Bank, CIA drug running, money laundering and covert funding.

392 pages, 6x9 paperback. Photo section. Index and Document section. $22.00. code: DIS

Please use item codes when ordering http://www.azstarnet.com/~aup

NEW BOOKS

SEDONA BEYOND THE VORTEX
by Richard Dannelley
Sedona Power Spot Vortex author Dannelley brings us this intriguing follow-up about Vortex phenomenon, Sacred Geometry, Soul Awareness, the Merkaba, the Medicine Wheel and more. A fascinating and visual book with all kinds of unusual information. Students of Vortex energy, the World Grid, Sacred Geometry and "Ascension" work should not miss this one.
154 pages, 9x12 paperback. Illustrated with grid maps, diagrams and photos. $12.00. code: SBV

ANCIENT EGYPTIAN SURVIVALS IN THE PACIFIC
by R.A. Jairazbhoy
Archaeologist and historian Jairazbhoy explores the evidence for ancient Egyptian voyages across the Indian Ocean and the Pacific in early prehistory. Jairazbhoy gives conclusive evidence that the Egyptians voyaged across the Pacific to North and South America and this book examines "the Egyptian imprint" that has been retained on many Pacific islands, including Easter Island. Other chapters on the Egyptian sources of Polynesian belief, Easter Island as a secret Egyptian trading base between Egypt and Peru.
98 pages, 6x9 paperback. Illustrated. Footnotes & Bibliography. $11.95. code: AESP

RAMESES III
Father of Ancient America
by R.A. Jairazbhoy
Archaeologist and historian Jairazbhoy brings us this fascinating and scholarly look at the evidence for ancient Egyptian voyages to the Americas in early prehistory. Packed with photographic and other evidence, Jairazbhoy reconstructs Rameses III's wish to find an earthly paradise. This adventure led him to the Americas, where the ancient Egyptians mingled with the native meso-American cultures.
148 pages, 6x9 paperback. Illustrated. Footnotes & Bibliography. $11.95. code: RAM3

MIND MACHINES YOU CAN BUILD
Move Things With Your Mind & Other Experiments
by G. Harry Stine
NASA consultant scientist G. Harry Stine guides you step-by-step in the easy building and the using of mind machines. He then compares their seemingly unexplainable action to current scientific knowledge. The latest research will help you to understand and use these centuries old-items, like dowsing rods, pendulums, and pyramids. This books explores modern-day Psychokinesis, the Hieronymous Machine, the Wishing Machine, more.
205 pages, 6x9 paperback. Illustrated. $15.95. code: MMYB

THE ENERGY WHEEL
Prove You Can Move Things With Your Mind
from G. Harry Stine's book
This is not a book, but a simple Energy Wheel device as described in G. Harry Stine's book Mind Machines You Can Build. It consists of a 2.5 inch metal rotor which stands on a plastic box, which is also the carrying case. Comes with an instruction booklet in a shrink-wrapped cardboard box.
Metal Wheel in Box. With Instructions. $7.95. code: TEWB

TAMING THE WILD PENDULUM
Includes a Free Brass Pendulum
by Drs. Tag & Judy Powell
With this book you can easily learn how to control and use the world's oldest success tool. You can learn to tap into your own inner consciousness and use a pendulum to explore the fascinating worlds of dowsing for lost objects and treasure, discovering water, oil, gold or other valuable minerals through the use of a pendulum, use the Powell Multi-Meter to ask questions on health, relationships and careers. The authors claim that their Powells Time Machine, included in the book, can allow the user to travel into the past or future with the pendulum. Comes with a brass pendulum shrink-wrapped inside the book.
200 pages, 6x9 paperback. Illustrated. Comes with Brass Pendulum. $19.95. code: TWP

Please use item codes when ordering http://www.azstarnet.com/~aup

THE LOST CITIES

LOST CITIES OF ATLANTIS, ANCIENT EUROPE & THE MEDITERRANEAN
David Hatcher Childress

Atlantis! The legendary lost continent comes under the close scrutiny of maverick archaeologist David Hatcher Childress. This sixth book in the internationally popular Lost Cities series takes us on quest for the lost continent of Atlantis. Childress takes the reader in search of sunken cities in the Mediterranean; across the Atlas Mountains in search of Atlantean ruins; to remote islands in search of megalithic ruins; living legengds and secret societies. From Ireland to Turkey, Morocco to Eastern Europe, or remote islands of the Mediterranean and Atlantic Childress takes the reader on an astonishing quest for mankind's past. Ancient technology, cataclysms, megalithic construction, lost civilizations and devastating wars of the past are all explored in this astonishing book. Childress challenges the skeptics and proves that great civilizations not only existed in the past, but the modern world and its problems are reflections of the ancient world of Atlantis.
524 pages, 6x9 paperback. Illustrated with 100s of maps, photos and diagrams. Bibliography & Index. $16.95. code: MED

LOST CITIES OF ANCIENT LEMURIA & THE PACIFIC
David Hatcher Childress

Was there once a continent in the Pacific? Called Lemuria or Pacifica by geologists, and Mu or Pan by the mystics, there is now ample mythological, geological and archaeological evidence to "prove" that an advanced, and ancient civilization once lived in the central Pacific. Maverick archaeologist and explorer David Hatcher Childress combs the Indian Ocean, Australia and the Pacific in search of the astonishing truth about mankind's past. Contains photos of the underwater city on Pohnpei, explanations on how the statues were levitated around Easter Island in a clock-wise vortex movement; disappearing islands; Egyptians in Australia; and more.
379 pages, 6x9, paperback. Photos, maps, and illustrations with Footnotes & Bibliography $14.95. code LEM

DAVID HATCHER CHILDRESS RADIO INTERVIEW
On the Lost Cities of North & Central America

In December of 1992, popular Lost Cities Series author, David Hatcher Childress, was interviewed live for six hours on the Laura Lee Radio Show, broadcast out of Seattle, Washington. The subject of the interview was David's book, Lost Cities of North and Central America, with special emphasis on the Smithsonian Institution's cover-up of American history. Other topics that were included in the interview, which also included live call-in questions, were pyramids around the world, the Rama Empire of India and Vimanas, Atlantis and Lemuria, UFOs, an Egyptian City in the Grand Canyon, and more! This audio interview comes on three high-quality 90 minute cassette tapes in boxes.
270 Minutes on 3 audio cassettes, $12.95 code: DHCR

24 hour credit card orders – call: 815 253 6390 ▪ fax: 815 253 6300 ▪ Email: aup@azstarnet.com

THE LOST CITIES SERIES

LOST CITIES OF NORTH & CENTRAL AMERICA
David Hatcher Childress

From the jungles of Central America to the deserts of the southwest… down the back roads from coast to coast, maverick archaeologist and adventurer David Hatcher Childress takes the reader deep into unknown America. In this incredible book: search for lost Mayan cities and books of gold; discover an ancient canal system in Arizona; climb gigantic pyramids in the Midwest; explore megalithic monuments in New England; and join the astonishing quest for the lost cities throughout North America. From the war-torn jungles of Guatemala, Nicaragua and Honduras to the deserts, mountains and fields of Mexico, Canada, and the U.S.A., Childress takes the reader in search of sunken ruins; Viking forts; strange tunnel systems,; living dinosaurs; early Chinese explorers; and fantastic gold treasure. Packed with both early and current maps, photos and illustrations. An incredible life on the road in search of the ancient mysteries of the past!
590 pages, 6 x9, paperback. Photos, maps, and illustrations with Footnotes & Bibliography $14.95. code NCA

LOST CITIES & ANCIENT MYSTERIES OF AFRICA & ARABIA
David Hatcher Childress

Across ancient deserts, dusty plains and steaming jungles, maverick archaeologist David Childress continues his world-wide quest for lost cities and ancient mysteries. Join him as he discovers forbidden cities in the Empty Quarter of Arabia, "Atlantean" ruins in Egypt and the Kalahari desert; a mysterious, ancient empire in the Sahara; and more. This is an extraordinary life on the road: across war-torn countries Childress searches for King Solomon's Mines, living dinosaurs, the Ark of the Covenant and the solutions to the fantastic mysteries of the past.
423 pages, 6 x9, paperback. Photos, maps, and illustrations with Footnotes & Bibliography $14.95. code AFA

LOST CITIES & ANCIENT MYSTERIES OF SOUTH AMERICA
David Hatcher Childress

Rogue adventurer and maverick archaeologist, David Hatcher Childress, takes the reader on unforgettable journeys deep into deadly jungles, windswept mountains and scorching deserts in search of lost civilizations and ancient mysteries. Travel with David and explore stone cities high in mountain forests and fantastic tales of Inca treasure, living dinosaurs, and a mysterious tunnel system. Whether he is hopping freight trains, searching for secret cities, or just dealing with the daily problems, of food, money, and romance, the author keeps the reader spellbound. Includes both early and current maps, photos, and illustrations, and plenty of advice for the explorer planning his or her own journey of discovery.
381 pages, 6x9, paperback. Photos, maps, and illustrations with Footnotes & Bibliography $14.95. code SAM

LOST CITIES OF CHINA, CENTRAL INDIA & ASIA
David Hatcher Childress

The real life "Indiana Jones," maverick archaeologist David Childress takes the reader on an incredible adventure across some of the world's oldest and most remote countries in search of lost cities and ancient mysteries. Discover ancient cities in the Gobi Desert; hear fantastic tales of lost continents, vanished civilizations and secret societies bent on ruling the world. Visit forgotten monasteries in forbidding snow-capped mountains with strange tunnels to mysterious subterranean cities! A unique combination of far-out exploration and practical travel advice; it will astound and delight the experienced traveler or the armchair voyager.
429 pages, 6 x9, paperback. Photos, maps, and illustrations with Footnotes & Bibliography $14.95. code CHI

Please use item codes when ordering http://www.azstarnet.com/~aup

MYSTIC TRAVELLER SERIES

IN SECRET MONGOLIA

Sequel to Men & Gods In Mongolia
Henning Haslund
Danish-Swedish explorer Haslund's first book on his exciting explorations in Mongolia and Central Asia. Haslund takes us via camel caravan to the medieval world of Mongolia, a country still barely known today. First published by Kegan Paul of London in 1934, this rare travel adventure back in print after 50 years. Haslund and his camel caravan journey across the Gobi Desert. He meets with renegade generals and warlords, god-kings and shamans. Haslund is captured, held for ransom, thrown into prison, battles black magic and portrays in vivid detail the birth of new nation. Haslund's second book Men & Gods In Mongolia is also available from Adventures Unlimited Press.
374 pages, 6x9 paperback. Illustrated with maps, photos and diagrams. Bibliography & Index. $16.95. code: ISM

MEN & GODS IN MONGOLIA

Henning Haslund
First published in 1935 by Kegan Paul of London, Haslund takes us to the lost city of Karakota in the Gobi desert. We meet the Bodgo Gegen, a God-king in Mongolia similar to the Dalai Lama of Tibet. We meet Dambin Jansang, the dreaded warlord of the "Black Gobi." There is even material in this incredible book on the Hi-mori, an "airhorse" that flies through the air (similar to a Vimana) and carries with it the sacred stone of Chintamani. Aside from the esoteric and mystical material, there is plenty of just plain adventure: caravans across the Gobi desert, kidnapped and held for ransom, initiation into Shamanic societies, warlords, and the violent birth of a new nation.
358 pages, 6x9 paperback, 57 photos, illustrations and maps. $15.95. code: MGM

DANGER MY ALLY

The Amazing Life Story of the Discoverer of the Crystal Skull
"Mike" Michell-Hegdes
The incredible life story of "Mike" Mitchell-Hedges, the British adventurer who discovered the Crystal Skull in the lost Mayan city of Lubaantun in Belize. Mitchell-Hedges was lived an exciting life: gambling everything on a trip to the Americas as a young man, riding with Pancho Villa, his personal quest for Atlantis, fighting bandits in the Caribbean and discovering the famous Crystal Skull.
374 pages, 6x9 paperback. Illustrated with maps, photos and diagrams. Bibliography & Index. $16.95. code: DMA

IN SECRET TIBET

Theodore Illion.
Reprint of a rare 30's travel book. Illion was a German traveller who not only spoke fluent Tibetan, but travelled in disguise through forbidden Tibet when it was off-limits to all outsiders. His incredible adventures make this one of the most exciting travel books ever published. Includes illustrations of Tibetan monks levitating stones by acoustics.
210 pages, 6x9 paperback, illustrated, $15.95. code: IST

DARKNESS OVER TIBET

Theodore Illion.
In this second reprint of the rare 30's travel books by Illion, the German traveller continues his travels through Tibet and is given the directions to a strange underground city. As the original publisher's remarks said, this is a rare account of an underground city in Tibet by the only Westerner ever to enter it and escape alive!
210 pages, 6x9 paperback, illustrated, $15.95. code: DOT

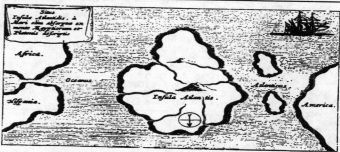

VIMANA AIRCRAFT
OF ANCIENT INDIA & ATLANTIS
David Hatcher Childress

Introduction by Ivan T. Sanderson
Did the ancients have the technology of flight? In this incredible volume on ancient India, authentic Indian texts such as the Ramayana and the Mahabharata, are used to prove that ancient aircraft were in use more than four thousand years ago. Included in this book is the entire Fourth Century BC manuscript Vimaanika Shastra by the ancient author Maharishi Bharadwaaja, translated into English by the Mysore Sanskrit professor G.R. Josyer. Also included are chapters on Atlantean technology, the incredible Rama Empire of India and the devastating wars that destroyed it. Also an entire chapter on mercury vortex propulsion and mercury gyros, the power source described in the ancient Indian texts. Not to be missed by those interested in ancient civilizations or the UFO enigma.
334 pages, 6x9 paperback, 104 rare photographs, maps and drawings. $15.95. code: VAA

ATLANTIS IN WISCONSIN
Frank Joseph

A group of sunken pyramids in a lake in Wisconsin lead the author to conclude that the legendary continent of Atlantis was actually Wisconsin. A strange ancient world of pyramids, sunken cities, ancient mining colonies and terrible wars, makes the prehistory of Wisconsin, Illinois and Michigan a fascinating place indeed. Is it Atlantis? Find out for yourself.Chapters include Outposts of Aztalan, Atlantis and the Copper Question, Paranormal Occurances, Psychic Overview of Rock Lake and Aztalan, more. 14 chapters in all. Nicely illustrated.
204 pages, 6x9 paperback. Illustrated. Footnotes & Bibliography. $14.95. code: AIW

BLINDSIDED
A Novel of Coming Earthchanges
Dick & Leigh Richmond-Donahue

Leigh Richmond's earlier novel, THE LOST MILLENIUM (published in 1969 by Ace books as SHIVA) was about the collapse of Atlantis and the fantastic technology that ultimately destroyed those who used it. This sequel is a prophetic story of the end of our current civilization: a world-wide war coupled by famine and earth-changes. As the Chinese and their allies take over the world, small survival communities with free energy struggle to survive...
171 pages, 6x9 tradepaper. $10.95. code: BLS

THE LOST MILLENIUM
How Did Atlanteans Tap the Free Energy of the Universe?
Walt & Leigh Richmond

Back in print after many years, this book, written as a novel, delves into the topic of Atlantean power sources, known as "solar taps." Did Atlantean science cause their destruction? Was the Great Pyramid built as one of the Atlantean "Solar Taps"? Asks the back cover of the book: "Did the Ancient Atlanteans have Free Energy?" "Why did Velikovsky place the last earth upheaval at about 5200 years ago?" "What made the continents break apart á la the Continental Drift theory." For students of unusual science, free energy, and Atlantis.
172 pages, 6x9 tradepaper. $12.95. code: LOM

ATLANTIS
A Definitive Study
George Firman

This book includes a study of Plato's texts, Phoenicians, dolphins, and an exhaustive study of ancient maps. Also included are chapters on plate tectonics, the Ursula Theory of Magnetic Accumulation, Edgar Cayce and Pole Shifts, plus more.
125 pages, 5x8 tradepaper, 45 diagrams, maps & photographs. $9.95. code: ADS

CRYPTOZOOLOGY

MYSTERIOUS AUSTRALIA
Rex Gilroy

The first and foremost book on unexplained phenomena down-under is now available. Rex Gilroy is Australia's Charles Fort, and his decades of research are reflected in this impressive book. Subjects include: UFOs and UFO bases; Yowies, Australia's Bigfoot; Giant Skeletons; Pre-Aboriginal Civilizations; Giant Lizards and other reptiles; Underground Mysteries; Little People; Mysterious Mountain Lions and Panthers; Loch Ness Monsters Down-Under; the Tasmanian Tiger; and more.
250 pages, 6x9. Tradepaper. Illustrated with photos, maps and drawings. Bibliography. $16.95. code: MYA

STRANGE NORTHWEST
NEW!

Newly Discovered, Supposedly Extinct, and Unconfirmed Inhabitants of the Animal Kingdom
by Chris Bader

The 38 chapters in this book cover various strange phenomena in the Pacific Northwest, covering Alaska, British Columbia, Idaho, Washington and Oregon Gathered from newspaper accounts, participant observations and personal interviews, Bader covers a wide spectrum of strangeness: UFOs, Bigfoot, seaserpents, ghosts, other strange phenomena.
256 pages, 6x9 paperback. Illustrated. Appendix & Bibliography. $12.95. code: SNW

TOM SLICK AND THE SEARCH FOR THE YETI
by Loren Coleman

Veteran cryptozoologist writer Loren Coleman tells us this curious true tale of the early Yeti-Big Foot expeditions to Tibet and the Himalayas by Texas millionaire Tom Slick. Coleman chronicles Tom Slick's major expeditions in search of the Yeti from 1956 to 1959 and reports on his mysterious CIA connections. Did the CIA use Tom Slick's Yeti expeditions as a cover for their operations in Tibet? Slick died in a mysterious plane crash in 1962. Coleman details Slick's searchs, footprint discoveries, and various other Yeti discoveries. Also includes an appendix: What Cryptozoology Is All About.
177 pp. 6x9 paperback. Illustrated with maps and photos. Bibliography & Index. $11.95. code: TSY

SASQUATCH BIGFOOT
NEW!

The Continuing Mystery
by Thomas N. Steenburg

Bigfoot research Thomas Steenburg's thick book on Sasquatch/Footage. Steenburg takes us around the world (though most of the book focuses on the Pacific Northwest) in search of stories and evidence for the giant hairy man-like beings called Sasquatch, Bigfoot, Yeti, Yowies, Almas, Skunk Apes and other things. These strange creatures have been reported in virtualy every state in the U.S. and Canada. Is their one in your back yard?
492 pages, 6x9 paperback. Illustrated with maps, photos & drawings. Appendix & Bibliography. $12.95. code: SBF

CRYPTOZOOLOGY

NEW!

RUMORS OF EXISTENCE
Newly Discovered, Supposedly Extinct, and Unconfirmed Inhabitants of the Animal Kingdom
by Matthew A. Bille

This book is an exhaustively researched yet lively examination of the least known animals in the world, all of them considered extinct, either now or in the past. From giant wombats and Tasmanian Tigers down-under to giant sloths and armadillos in South America, this book covers mystery animals and recently discovered survivors of alleged exinction. This book shows how resilient animals can be and that we should be sceptical about declarations of extinction.
218 pages, 6x9 paperback. Illustrated. Appendix & Bibliography.
$12.95. code: ROE

NEW!

MONSTER! MONSTER!
A Survey of the North American Monster Scene
by Bettey Sanders Garner

This book is mainly about Sea and Lake monsters in Canada and the U.S. but also includes chapters on living pterodactyls and Bigfoot. Chapters on the Lake Monster of Madison, Wisconsin, the White River Monster, the Mackinac monster, the Madrona Monster, Sea Serpents in the Gulf of Mexico, Sea Serpents of the East Coast, Sea Serpents of the West Coast, Canadian Lake Monsters, more. List of sightings starting in 1609 in the back.
190 pages, 6x9 paperback. Illustrated. Appendix & Bibliography.
$12.95. code: MOMO

NEW!

ON THE TRACK OF THE SASQUATCH
Newly Discovered, Supposedly Extinct, and
Unconfirmed Inhabitants of the Animal Kingdom
by John Green

Well-known cryptozoologist John Green brings us this large format book on the search for those hairy giants of the Pacific Northwest. Well illustrated, Green takes on an exciting adventure on the track of Sasquatch.
64 pages, 9x11 paperback. Illustrated. Appendix & Bibliography. $9.95
code: OTS

NEW!

ENCOUNTERS WITH BIGFOOT
by John Green
Well-known cryptozoologist John Green continues on his quest in this large format book. More tales of encounters with the hairy giants of the Pacific Northwest, most of them quite recently.
64 pages, 9x11 paperback. Illustrated. Appendix & Bibliography. $9.95. code: EWB

24 hour credit card orders – call: 815 253 6390 ▪ fax: 815 253 6300 ▪ Email: aup@azstarnet.com

THE GIANTS OF GAIA
by Nicholas Mann & Marcia Sutton, Ph.D.

This large format book looks at the subtle and not so subtle forces that have formed the "Giants of Earth." From the European megaliths of old, through the the Effigy Mounds of North America, to the Songlines used the Australian Aboriginals today, we learn to feel the forces at work. We learn how to re-enchant the landscape, awaken our local giants, and become more harmonized with our locales and their inhabitants. Fabulously illustrated with over 50 photographs, map overlays and line drawings.

182 pages, 9x11 paperback. Glossary. $14.95. code: GOG

INTO THE CRYSTAL
The Miracles of Peter Sugleris
by Berthold E. Schwarz, M.D.

Dr. Berthold Schwartz's many year study of Peter Sugleris, one of the few documented telekinetics alive today. Like Sai Baba, Sugleris has the amazing ability to mentally levitate and teleport objects. Under Schwartz's supervision Sugleris levitated and bent keys, levitated other objects, bent steel spikes, teleported objects and ultimately levitated himself on camera. 58 photos to document the text.

244 pages, 6x9 paperback. Heavily illustrated with photos, drawings and diagrams. $19.95. code: ITC

SEDONA POWER SPOT VORTEX
& MEDICINE WHEEL GUIDE
Richard Dannelley

Not only does this book explore the magic and mystery of the Vortices in Sedona, Arizona , but it explains how vortices work, how they effect our minds and bodies, and how the natural energies of the earth can be used. Chapters in this fascinating book include information on crystals, dowsing, vortex mythology, Medicine Wheels and their uses, geomancy, shamanism and the Rainbow Warrior, and more.

112 pages, 6x9 tradepaper, with bibliography. Illustrated with photos, maps and line drawings, $12.95 code: SPSV

SACRED THEORY OF THE EARTH
Thomas Frick

A collection of works on geomancy, sacred geology, The Egyptian Book of the Dead, Chinese dragon lines, an inclined Galactic Light Pond in Afghanistan, geomantic art and more.

264 pages, 6x9 tradepaper, illustrated with diagrams, maps & photographs. $9.95. code: STE

HOLY ICE
Bridge to the Subconcious
Frank Dorland.

The world's formost crystal expert, Frank Dorland, brings us this definitive work on rock quartz crystal. Dorland bridges many topics, including the famous crystal skull found at the lost city of Lubaantun, ancient magic lore concerning crystals, crystal healing, the making of artificial rock crystals, and most importantly, Dorland discusses the matter-of-fact uses of crystals in high technology. In an important chapter for the New Age scientist, Dorland discusses crystal oscilators, crystal autoclaves, and Catoptromancy (we didn't know what that was either). More on divination, charging crystals, crystal balls, chakras, more.

193 pages, 6x9 tradepaper, illustrated with drawings & photos, bibliography & glossary. $12.95. code: HYI

CIRCULAR EVIDENCE
Pat Delgado & Colin Andrews.
In the summer of 1981, Pat Delgado brought mysterious circular impressions in the fields at Cheesefoot Head, Hampshire to the attention of the British press. Since then, similar beautiful, symmetric circles in southern England and around the world have transformed initial curiosity into a full-blown investigation. Pat Delgado and Colin Andrews have compiled a compelling photographic record of the enigma. They follow with an equally compelling, and objective, discussion of its curious details. This book is sure to delight all interested by this fascinating phenomenon.
191 pages, 6x9 paperback, numerous photographs, mostly in color with drawings. $16.95. code: CEV

CROP CIRCLE SECRETS
Edited by Donald Cyr
This exciting book is a large format, highly illustrated compilation on crop circles and their related phenomenon. Includes a number of discussions on the relationships to ancient megaliths, ancient crop circles, the importance of magnetic field lines, King Arthur's crop circle, the Jupiter Canopy model, and other strange vortex effects.
80 pages, 8x10 paperback, 100 photos, illustrations and maps. $9.95. code: CCS

AMERICA'S FIRST CROP CIRCLE
Crop Circle Secrets Part Two
Edited by Donald Cyr
This compilation of articles goes beyond normal crop circle phenomena to discuss weird electromagnetic weather anomalies, "whistlers," American crop circles and Nikola Tesla and crop circles. Stonehenge Decoded author Gerald S. Hawkins writes several of the articles, plus a link between crop circles and ley lines is shown. Packed with illustrations and photographs.
96 pages, 8x10 trade-paperback, Illustrated. $9.95. code: AFC

YHWH
A Book On Ancient Electricity
Jerry Ziegler
This book is a scholarly look at the Old Testament and the use of electricity and other high tech devices in ancient times. In 21 chapters, Ziegler has made an impressive study of the Ark of the Covenant; Water and Electricity; High Tech devices in ancient civilizations and this high technology, the Dioskouri; Archeon; the Hymn to Belit; more.
161 pages 6 x9 tradepaper , illustrated with references & bibliography $9.95 code: YHWH

INDRA GIRT BY MARUTS
Electrical Phenomena in the Rig Veda
Jerry Ziegler

Jerry Ziegler second book after YHWH, INDRA GIRT BY MARUTS, uses the Rig Veda to demonstrate the nature of earlier times when the divine manifested through electrical phenomena at anient rites. As God the Father the divine emanated in St. Elmo's Fire on the mountain tops. As the Holy Ghost the divine light shown in the Ark of the Covenant in the temples house in the cities. As both these forms of the divine failed at the end of the earlier era the priesthoods needed a Savior which they found in the Son. For all those interested in ancient electrics and technology.
277 pages. 6x9 Tradepaper. Bibliography. $12.95. code: IGM

MYSTERIOUS FIRES AND LIGHTS
Vincent Gaddis
Gaddis's classic book is back in print with chapters on Strange conflagrations that have destroyed entire cities; the antics of lethal lightening and intelligent fireballs; Living UFOs; Will-o'-the-Wisps and ghost lights; spontaneous human combustion and supernatual arson; firewalkers and salamanders; more.
178 pages. 6x9 tradepaper. $11.95. code: MFL

24 hour credit card orders – call: 815 253 6390 ▪ fax: 815 253 6300 ▪ Email: aup@azstarnet.com

ANTI-GRAVITY

THE ANTI-GRAVITY HANDBOOK

Edited by David Hatcher Childress, With Arthur C. Clark, Nikola Tesla, T.B. Paulicki, Bruce Cathie, Leonard G. Cramp and Albert Einstein

The new expanded compilation of material on Anti-Gravity, Free Energy, Flying Saucer propulsion, UFOs, Suppressed Technology, NASA Coverups and more. Highly illustrated with patents, technical illustrations, photos and more, this revised and expanded edition has more material, including photos of Area 51, Nevada, the government's secret testing facility. This classic on weird science is back in a 90s format!

- How to build a flying saucer.
- Read about Arthur C. Clarke on Anti-Gravity.
- learn about crystals and their role in levitation.
- Secret government research and developement.
- Nikola Tesla on how anti-gravity airships could draw power from the atmosphere.
- Bruce Cathie's Anti-Gravity Equation.
- NASA, the Moon and Anti-Gravity. Plus more.

230 pages, 7x10 tradepaper, Bibliography/Index/Appendix. Highly illustrated with 100's of patents illustrations and photos, $14.95. code: AGH

ANTI-GRAVITY & THE WORLD GRID

Edited by David Hatcher Childress

Is the earth surrounded by an intricate electromagnetic grid network offering free energy? This compilation of material on the earth grid, ley lines, and world power points contains chapters on the geography, mathematics, and light harmonics of the earth grid. Learn the purpose of ley lines and ancient megalithic structures located on the grid. Discover how the grid made the Philadelphia Experiment possible. Explore Coral Castle and many other mysteries; Including, acoustic levitation, Tesla Shields and Scalar Wave weaponry. Browse through the section on anti-gravity patents, and research resources.

274 pages, 150 rare photographs, diagrams and drawings, 7x10 paperback, $14.95. code: AGW

ANTI-GRAVITY & THE UNIFIED FIELD

Edited by David Hatcher Childress

Is Einstein's Unified Field the answer to all of our energy problems? Explored in this compilation of material is how gravity, electricity and magnetism manifest from a unified field around us. Why artificial gravity is possible; Secrets of UFO propulsion; free energy; Nikola Tesla and anti-gravity airships of the 20's and 30's; Flying saucers as superconducting whirls of plasma; anti-mass generators; vortex propulsion; suppressed technology; government cover-ups; gravitational pulse drive, spacecraft & more.

240 pages, 7x10 paperback,130 rare photographs, diagrams and drawings, $14.95. code: AGU

TAPPING THE ZERO POINT ENERGY

Free Energy & Anti-Gravity in Today's Physics
Moray B. King

The author, a well-known researcher, explains how free energy and anti-gravity are possible with today's physics. The theories of the zero point energy show there are tremendous fluctuations of electrical field energy imbedded within the fabric of space. This book shows how in the 1930s inventor T. Henry Moray could produce a fifty kilowatt "free energy" machine; how an electrified vortex plasma creates anti-gravity; how the Pons/Fleischmann "cold fusion" experiment could produce tremendous heat without fusion; and how certain experiments might produce a gravitational anomaly.

170 pages, 6x9 tradepaper, Illustrated with 60 diagrams and drawings. $9.95. code: TAP

Please use item codes when ordering http://www.azstarnet.com/~aup

ANTI-GRAVITY & UFOS

MAN-MADE UFOS 1944—1994
Fifty Years of Suppression
Renato Vesco & David Hatcher Childress
A comprehensive and in-depth look at the early "flying saucer technology" of Nazi Germany and the genesis of early man-made UFOs from the captured German scientists. Examine escaped battalions of Germans creating secret communities in South America and Antarctica to todays state-of-the-art "Dreamland" flying machines. Heavily illustrated, this astonishing book blows the lid off the "Government UFO Conspiracy" and explains with technical diagrams the technology involved. Examined in detail are secret underground airfields and factories; German secret weapons; "suction" aircraft; the origin of NASA; gyroscopic stabilizers and engines; the secret Marconi aircraft factory in South America; and more. Not to be missed by students of technology suppression, secret societies, anti-gravity, free energy conspiracy and World War III Introduction by W.A. Harbinson, author of the Dell novels GENESIS and REVELATION.
518 pages, 6x9 tradepaper. Illustrated. Index & footnotes. $16.95. code: MMU

ELECTROGRAVITICS SYSTEMS
Reports on a new propusion methodology
With a Foreward by Elizabeth Rauscher, Ph.D.
Edited by Thomas Valone
An anthology of two unearthed reports of the secret work of T. Townsend Brown shortly after WWII with diagrams and explanations by well-known free-energy and anti-gravity researcher Tom Valone. The first report, Electrogravitic Systems was classified until recently, and the second report, The Gravitics Situation, is a fascinating update on Brown's anti-gravity experiments in the early 50s.
Also included Dr. Paul La Violette's research paper on the B-2 as a modern-day version of an eletrogravitic aircraft—a literal U.S. Anti-Gravity Squadron!
116 pages, 6x9 tradepaper, illustrated with patents, graphs & diagrams. $15.00. code: EGS

ETHER TECHNOLOGY
A Rational Approach to Gravity Control
Rho Sigma
This classic book on Anti-Gravity & Free Energy is back in print and back in stock. Written by a well-known American scientist under the pseudonym of "Rho Sigma," this book delves into International efforts at gravity control and discoid craft propulsion. Before the Quantum Field, their was "Ether." This small, but informative books has chapters on John Seale and "Searle discs;" T. Townsend Brown and his work on Anti-Gravity; Ether-Vortex-Turbines; and more. Includes a forward by former NASA astronaut Edgar Mitchell. Don't miss this classic book!
108 pages, 6x9 tradepaper, illustrated with photos & diagrams. $12.95. code: ETT

THE NEW GRAVITY
Unifying Gravity with Light
Kenneth G. Salem
Quantum Physicist Kenneth Salem's book on the acceleration, force, mass and the Unifying of Gravity with Light. Theories on the speed of light, why the universe expands, how mass is is created, the Momentum-Position dilemma of the electron and the Unified Field. Is some Outside Force driving each and every particle throughout the Universe? Are atoms really empty? the Philoscity of Light, more.
189 pages, 6x9 paperback. Illustrated with diagrams & photos. Bibliography & Index. $12.00. code: TNG

FREE-ENERGY

THE FREE-ENERGY
DEVICE HANDBOOK
A Compilation of Patents & Reports

THE FREE-ENERGY DEVICE HANDBOOK
A Compilation of Patents and Reports
David Hatcher Childress

A large format compilation of various patents, papers, descriptions and diagrams concerning free-energy devices and systems is a visual tool for experimenters and researchers into magnetic motors and other "over-unity" devices. With chapters on the Adams Motor, the Hans Coler Generator, cold fusion, superconductors, "N" machines, space-energy generators Nikola Tesla, T. Townsend Brown, and the latest in free-energy devices. Packed with photos, technical diagrams, patents and fascinating information, this book belongs on every science shelf. With energy and profit being a major political reason for fighting various wars, Free-Energy Devices, if ever allowed to be mass-distributed to consumers, could change the world! Get your copy now before the Department of Energy bans this book!
292 pages, 8x10 tradepaper. Profusely Illustrated. Bibliography & Appendix. $16.95. code: FEH

UNIVERSAL
LAWS
NEVER BEFORE
REVEALED:
KEELY'S
SECRETS

KEELY'S SECRETS:
Universal Laws Never Before Revealed
Edited by Dale Pond

A large format, heavily illustrated book on the understanding and using of the Science of Sympathetic Vibration. Back around 1890 an inventor named John Keely invented a free energy device that worked on "sympathetic vibration" to create anti-gravity and free-energy effects. Keely developed a surprising number of devices, all of which are depicted and described here in text, photos and diagrams. Chapters on levitation, etheric forces oscillation vs. vibration, music & harmonics, synthesized wave forms, dangers of ultrasonic energy, sympathetic oscillation, much more. Free-energy & anti-gravity scientists should not miss this book!
285 pages, 9x11 paperback. Heavily illustrated with photos, diagrams, and newspaper articles. Bibliography & Index. $19.95. code: KES

THE HOMOPOLAR HANDBOOK
A Definitive Guide to Faraday Disk & N-Machine Technologies
Thomas Valone, M.A., P.E.

The second book from Tom Valone, author of ELECTRO-GRAVITIC SYSTEMS and well-known free-energy/anti-gravity scientist is a mile-stone work on permanent magnet free-energy devices. This book is packed with technical information with chapters on the Faraday Disc Dynamo, Unipolar Induction, the "field rotation paradox," the Stelle Homopolar Machine, the Trombly-Khan Closed-Path Homopolar Generator, the Sunburst Machine, experimental results with various devices, more.
180 pages, 6x9 Tradepaper. Illustrated with diagrams, photos & patents. References, Appendix & Index. $20.00. code: HPH

FIELD EFFECT
The Pi Phase of Physics & The Unified Field
Leigh Richmond-Donahue

Leigh Richmond's brief book is an analysis of the structure of the electron which brings to light the anatomy of black holes, superstrings, and the techniques of evolution. Leigh shows how the "Field" is complete around the universe and all living things. Our galaxy, ourselves, and the electrons of which we are built, function on logical pattern and operative system. Once you find that pattern, the rest falls into place, including free energy, anti-gravity and human enlightenment.
77 pages, 6x9 tradepaper. Illustrated with photos & diagrams. $11.95. code: FEF

Please use item codes when ordering http://www.azstarnet.com/~aup

TESLA TECHNOLOGY

$16.95 code: FINT

THE FANTASTIC INVENTIONS OF NIKOLA TESLA
Nikola Tesla with additional material by David Hatcher Childress

This book is a virtual compendium of patents, diagrams, photos and explanations of the many incredible inventions of the originator of the modern era of electrification. The book is a readable and affordable collection of his patents, inventions and thoughts on free energy, anti-gravity, and other futuristic inventions. Covered in depth, often in Tesla's own words, are such topics as wireless transmission of power, death rays, and radio-controlled airships. Students of German bases in Antarctica and South America, will appreciate the last chapter of the book which deals with a secret city built at a remote jungle site in South America by one of Tesla's students, Guglielmo Marconi. Marconi's secret group claims to have built flying saucers in the 1940s and to have gone to Mars in the early 1950s! A portion of one chapter deals with various theories on Tesla's system and the ancient Atlantean system of broadcasting energy through a grid system of obelisks and pyramids. A fascinating concept comes out of this chapter that the engineers had to wear a protective metal head-shield while in these power-plants, hence the Egyptian Pharoah's head covering as well as the Face on Mars! Students of free energy, Anti-gravity, Mars and Atlantis, don't miss this book!
342 pages, 6x9 paperback. Highly illustrated with bibliography & appendix.

PRODIGAL GENIUS: THE LIFE OF NIKOLA TESLA
John O'Neil

First published in 1944, shortly after Tesla's death, this biography of the great inventor was the first to tell the tale of the brilliant and eccentric personality that was Nikola Tesla. O'Neil knew Tesla, who once remarked to him, "You understand me better than any man alive."
326 pages, 6x9 tradepaper. List of Patents & Index. $14.95. code: PRG

INTERNATIONAL TESLA SYMPOSIUM PROCEEDINGS 1988
edited by Steven R. Elswick.

The first collection of material from the International Tesla Symposiums held in Colorado every two years, it includes papers on the transmission of electricity through the earth without wires, Tesla and particle beam weapons, advanced gravitics, levitation, Maxwell's lost Unified Field theory, radiant energy, Tesla Coils and much more. 21 articles in all. Like having an encyclopedia of far-out science on your shelf!
304 pages, 9x11 hardback, illustrated with rare photographs & diagrams. $49.95. code: ITS88

INTERNATIONAL TESLA SYMPOSIUM PROCEEDINGS 1990
edited by Steven R. Elswick.

This second volume of symposium papers includes Tesla Wave Physics, High Voltage Concentric Field Generator Design, the Tesla Disc Turbine, Tesla and electron beam weapons, nonlinear dynamics, advanced gravitics and Zero Point Energy. 21 articles in all.
304 pages, 9x11 hardback, illustrated with rare photographs & diagrams. $49.95. code: ITS90

INTERNATIONAL TESLA SYMPOSIUM PROCEEDINGS 1992
edited by Steve R. Elswick

The latest in high tech information on Tesla Technology, anti-gravity, free-energy and beam weaponry. Articles on Tesla Coils, The Black Hole Antenna, Electrostatics: A Key to "Free Energy", The Laser Cel, Moray B. King on the Progress in Zero Point Energy Research, Tesla's Particle Beam Technology, more. 18 all new articles in all in a durable hardback format. Heavily Illustrated.
200 pages, 9x11 hardback. Illustrated. Footnotes & Bibliography. $49.95. code: ITS92

24 hour credit card orders – call: 815 253 6390 ▪ fax: 815 253 6300 ▪ Email: aup@azstarnet.com

TESLA TECH & ANTI-GRAVITY

TESLA TECHNOLOGY SERIES VOL. 1:

The Wireless Transmission of Power.
Nikola Tesla.
Originally published in June, 1900 in Century Magazine, this small book outlines Tesla's master blueprint for the world. It includes chapters on the transmission of electricity through the earth without wires, the secret of tuning the electrical oscillator, unexpected properties of the atmosphere, and some strange experiments.
92 pages, 6x9 paperback, illustrated with rare photographs & diagrams. $9.95. code: TESL

NIKOLA TESLA:

See New Books page 5

Lecture Before the New York Academy of Sciences — April 6, 1897
Edited by Leland Anderson
Tesla historian Leland Anderson has pieced together this never before Tesla lecture in which he touches on a wide range of topics. Tesla begins by speaking on the recently discovered X-ray by Lenard and Roentgen and then his commentary deals with the high frequency resonators that were used in conjunction with his work, plus clear descriptions of stroboscopic instruments he designed for measurement of frequency and phase. Other topics addressed include wireless receiving methods and the genesis of Tesla's particle beam weapon of 1937. With 120 drawings of specially constructed vacuum tubes, many being of the Lenard type and also the single-electrode type of his own design.
123 pages. 6x9 paperback. Diagrams, schematics & illustrations. References & Index. $12.95. code: NTL

ANTI-GRAVITY: THE DREAM MADE REALITY

The Story of John R.R. Searl
John Thomas Jr.
An important, large format book on the amazing anti-gravity work of British scientist John Searl. Seven chapters tell the story of Searl's invention, his troubles with the British authorities that lead to his arrest and imprisonment, and the road back to starting over. This book contains rare photos and diagrams of Searl's flying disc; plus good technical information on Searl's "Law of Squares," the SEG electric generator; his anti gravity theories; more.
110 pages, 8x11 paperback. Illustrated with photos, schematics & diagrams. $25.00. code: AGD

SPACESHIP CONSPIRACY

George Knap.
The story of Orbital Space Propulsion and Canadian inventor George Knap's fifteen-year struggle with the suppression of his "anti-gravity" device. Orbital Space Propulsion is Knap's term for his centrifugal drive that creates a directional, anti-gravity effect. Knaps "Orbital Space Propulsion Drive" is similar to the Dean Drive or the Cook Drive (see The Death of Rocketry, this catalog, page 9). After his patent was finally issued (#4,087,064, 1978) he was harrassed by secret service, accused of being a spy, and his invention suppressed. This amazing book gives Knap's entire story with diagrams, patents, photos and other illustrations. A must for all anti-gravity, free energy and Tesla buffs.
100 pages, 6x9 paperback. Illustrated. $9.95. code: SPC

ANTI-GRAVITY ON A DISK

Frank Znidarsic
Elementary Anti-Gravity author Frank Znidarsic brings us this IBM format computer disk containing over 1 megabyte of information in 12 chapters, 30 illustration, one sound byte, and two animations. The information is presented in a manner that will be accessible to the novice and is thorough enough to please the most advanced. Discover how Edward P. Tryon's theory about the genesis of the universe may be used to produce free energy. Learn about the far reachin g ideas of Harold E. Puthoff, See and hear Frank J. Stenger's ball lightning machine, View a plasma ball in a microwave cavity, more.
Computer Disk in Bubblepack. $15.00. code: AGDK

Please use item codes when ordering http://www.azstarnet.com/~aup

ALTERNATIVE SCIENCE

THERE ARE NO ELECTRONS
Electronics For Earthlings
Kenn Amdahl
"The mysteries of Electricity are revealed in this bizzare and often amusing text-book-in-a clown-suit." Whole Earth Review. Amdahl has created a fun and informative book on electricity and its various electronic devices. Chapters are on crystal radio sets; vacuum tube diodes; cats whiskers diodes; the intergallactic steam train; transformers, coils and capaciters; more.
322 pages, 6x9 tradepaper. Illustrated with schematics & diagrams. $12.95. code: TANE

DIMENSIONS OF RADIONICS
A Manual of Radionic Theory and Practice
David Tansley, D.C. in collaboration widh Malcolm Rae and Aubrey T. Westlake
The authors expound largely on the health side of radionics— the subtle energy nature and consitution of the human body with emphasis placed upon diagnosis of the spiritual, mental and physical disposition of the individual via the ether fields— the broadcasting of subtle healing energies (homeopathic, flower essence, color or gem stone) back to the paient. Also contains information on the energies, forces & thought forms; the seven dimensions of the Mental Plane; chakras and radionic treatment; diagrams of various devices, more.
206 pages, 6 x9 paperback. Illustrated with charts and diagrams. $16.95 code: DMR

MY SEARCH FOR RADIONIC TRUTHS
By R Murry Denning
This book is something of a "Radionics Hand book," describing in detail, with illustrations, the what, how and why of the obscure science of Radionics. Twelve chapters in the book deal with basic principles, early pioneers in Radionics such as S.W. Tromp, Dr. Ruth B. Drown, Darrell Butcher and others. Featured are Dinash Ghadiali and his "Spectro-Chrome Therapy; Marguerite Maury on "How to Dowse,' and "Practical Radiesthesia"; The Enigma of Numbers; Can Yoga & Alchemy Meet?; Radionics and Modern Science; plus more.
118 pages, 6 x9 tradepaper, Illustrated with Bibliography. $9.95 code: SRT

SCIENTIFIC VORTEX INFORMATION
An MIT-Trained Scientist's Program
by Peter A. Sanders, Jr.
Vortex energy, in the Earth and within living creatures, is explained by Sanders in this illustrated book. Also included in the book is a chapter on how Native Americans used the vortices. The author lives in Sedona, Arizona, famous for its natural vortices, so a large part of this slim book is spent discussing each vortex that occurs there.
64 pages, 6x9 tradepaper, illustrated, $12.95 code: SVI

COLD FUSION IMPACT
In the Enhanced Energy Age
By Hal Fox
An impressive collection of material on cold fusion, this book shares the far-reaching vision of all the changes that low-cost, clean, abundant energy will bring to the entire world. Hal Fox has been collecting data on cold fusion ever since the Pons Fleischmann experiment, and this book includes a free computer disc "Fusion Facts" (a $25 value) which is a data base listing over 1200 articles and scientific papers on cold fusion, most of them supporting the reality of cold fusion. An important free energy volume, this book and disc are important tools on new enhanced energy systems of tomorrow. The authors at the Fusion Information Center say that it will herald the greatest change in technology ever witnessed by mankind!
392 pages, 6x9 hardcover, with computer disc. Profusely Illustrated. 24.95 code: CFI

24 hour credit card orders – call: 815 253 6390 ▪ fax: 815 253 6300 ▪ Email: aup@azstarnet.com

STRANGE SCIENCE

THE PYRAMIDS OF MONTAUK

Explorations In Consciousness
by Preston Nichols & Peter Moon

During WWII was an invisibility attempt called the Philadelphia Experiment. Afterwards was the now famous time travel experiments named after the underground base at Montauk Point on Long Island. Book III in the Montauk series summarizes the events of the first two books and then takes the reader on an even more spectacular journey. The discovery of ancient pyramids at Montauk leads to a connection with ancient Egypt and its position as a gateway into other dimensions. Like a psychic detective story beyond the occult, venture into an unprecedented investigation of the mystery schools of the earth and their connection to Egypt, Atlantis, Mars and the star Sirius. Chapters on new psychotronic weapons, the history of Mars, the strange death of Ian Fleming (of James Bond) in connection with the Philadelphia Experiment, underground at the Montauk Base, more.

257 pages. 6x9 paperback. Photos, maps, illustrations. Bibliography. $19.95. code: POM

THE MONTAUK PROJECT

Preston Nichols with Peter Moon.

This book chronicles the alleged time-travel experiments of the U.S. Government. Starting with the Philadelphia Experiment of 1943, invisibility experiments were conducted aboard the USS Eldridge that resulted in full-scale teleportation of the ship and crew. Forty years of massive research ensued, culminating in bizarre experiments at Montauk Point that actually manipulated time itself. The controversial lectures by Al Bielek on the Montauk Project and the Philadelphia experiment are similar to the information in this book. This convincing book includes diagrams and photos of the time-travel devices themselves, plus photocopies of documents and schematic diagrams. Highly recommended. If you ever wanted to build a time-travel device, you'll need this book!

160 pages, 6x9 trade-paperback, Illustrated. $15.95. code: TMP

MONTAUK REVISITED

Adventures in Synchronicity
Preston B. Nichols & Peter Moon

This sequel to The Montauk Project continues the pursuit of the mystery of Time Travel; the Philadelphia Experiment; and the Montauk Military Base near New York City. Montauk Revisited goes beyond the original time travel experiments and reveals the mysterious associations of the Cameron Clan with the genesis of American rocketry, the bizarre history of the electronic transistor and the magick of Aleister Crowley, Jack Parsons and Ron L. Hubbard; more.

254 pages, 6 x9 paperback. Appendix, Bibliography & Index. $19.95. code: MRV

CASEBOOK ON ALTERNATIVE 3

Jim Keith

UFOs, Secret Societies and World Control Jim Keith Conspiracy and UFO expert, Jim Keith (editor of The Gemstone File) has assembled a powerful and fascinating book into the shadowy world UFO secrets, missing scientists, Cold War collusion between the U.S. and the Soviets, and weird bases on the Moon and Mars. I n 1975 an unusual television documentary called ALTERNATIVE 003 was aired on British television which was later followed by a paperback book. The documentary and book detailed the astonishing story of how top scientists around the world were being abducted to provide personnel for secret underground UFO manufacturing bases; how the rich elite of the world have initiated a secret space program of space migration; how secret joint USA-Russian programs have established bases on the Moon and Mars; how UFOs are actually secret government aircraft manufactured in various underground factories on Earth and elsewhere; info on Nazi Flying Saucers; and more. Whether you have the original paperback book or not, don't miss this amazing book! 21 chapters in all.

160 pages, 6x9 tradepaper. Bibliography. $12.95. code: CA3

Please use item codes when ordering http://www.azstarnet.com/~aup

NEW VIDEOS

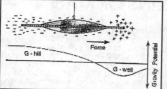

FREE ENERGY & PROPULSION OVERVIEW

Video
with Tom Valone

Physcist and author Tom Valone presents a slide show lecture on Free-Energy and Anti-Gravity concepts at a 1995 convention. Free-Energy and Anti-Gravity discussed in detail, more.

70 min. video. Color VHS format. $24.95. code: FEPV

THE ANTI-GRAVITY CONSPIRACY VIDEO

a collection of various video clips

This collection of various video clips, some of them silent, home movies, takes us into the forbidden world of anti-gravity propulsion, suppressed technology and electrically powered flying saucers. See the entire T. Townsend Brown footage taken at the Bahnson Labs between 1958 and 1960. In this historic silent movie footage, we see T. Townsend Brown flying electrified discs in the Bahnson Lab while "Men in Black" stand watching. Included are other television and movie clips relating to anti-gravity devices, NASA cover-ups, more.

Aprox. 80 min. video. Color VHS format. $19.95. code: TAGV

WILHELM REICH & THE UFO PHENOMENA

Video of Reich in the Arizona Desert 1954-55
with Eva Reich

A candid and intimate discussion of Wilhelm Reich's final years, including orgone energy, UFO sightings, cloudbusting, scientific and legal persecution with his daughter, Eva Reich. Eva discusses her father's top-secret expedition of weather modification experiments that took place in Tucson, Arizona in 1954 for the government. Eva discusses what it was like growing up with her father and his untimely death in a Federal Prison. Includes Time Lapse Films from Reich's weather modification experiements in Tucson.

One hour video. Color & B&W, VHS format. $35.00 code:WRUV

UNDERGROUND BASES & TUNNELS

The Video
with Richard Sauder

Richard Sauder takes us into the strange world of the massive underground bases and tunnels built around the United States by the U.S. goverment. Sauder uses little-known government documents in the public record to show that the Pentagon has built a vast network of underground tunnels and bases that are apparently linked to the current wave of UFO phenomenon now sweeping America. Sauder discusses the locations of the bases, the tunneling technology involved, cattle mutilations, more.

Aprox. 80 min. video. Color VHS format. $24.95. code: UBTV May Release

ENTER DARKNESS: ENTER LIGHT

Documentary

This is the video to go along with the popular book 5-5-2000: Ice the Ultimate Disaster by Richard Noone. Noone himself is interviewed extensively in this video on a possible poleshift and resulting cataclysms predicted to occur on May 5, 2000 because of a rare planetary alignment and an unstable earth. Also in this video is material on the construction of the Great Pyramid of Egypt and the evicence for ancient cataclysms. In depth interviews with geologists, astronomers, psychics, and futurists give sound advice on the coming earthchanges and radical change that is predicted in the near future. Interviews with Richard Noone, David Hatcher Childress, Jean Houston, Richard Kieninger, Dolores Cannon, Annie Kirkwood, Dr. Gay Luce and more.

110 minutes. VHS Video. $25.00. code: EDLV

Please use item codes when ordering http://www.azstarnet.com/~aup

NEW VIDEOS

An NBC Television Special

THE Mysterious ORIGINS OF MAN

hosted by CHARLTON HESTON

CONTROVERSIAL EVIDENCE THAT COULD REWRITE MAN'S HISTORY

THE MYSTERIOUS ORIGINS OF MAN

Video hosted by Charlton Heston

This home version of the NBC video aired in late February 96 is from Bill Cote Studios, the same studio that brought you the Mystery of Sphinx video, also with Charlton Heston. This program looks at living dinosaur survivals, footprints with man and dinosaurs, documented cases that man may be millions of years older than the theory of evolution accepts, evidence that a lost civilization may exist beneath the ice of Antarctica and a close look at the astonishing ruins of Tiahuanaco in the high Andes. Recent discoveries indicate that it may be thousands of years older than historians have acknowledged. Interviews with David Hatcher Childress, Graham Hancock of Finger Prints of the Gods, Richard Thompson of Forbidden Archaeology, more.
47 minutes, Color & B/W VHS video. $19.95 code:MOV

MYSTERIOUS ORIGINS OF MAN DOUBLE TAPE SET

2 Tape Set with companion video

The two-tape set comes with the above video plus a second companion video that features an additional hour of material that was not included in the NBC television broadcast version. This second tape contains more interviews with Hancock, Thompson and Childress plus an interview with Linda Molton Howe who discusses an airforce interview about alien intervention in mankind's affairs. Featured in this video is an iron hammer found in 130 million year old rock strata, reports of living pterodactyls from Western Africa and New Guinea, other material on living dinosaurs, anomalous artifacts and skeletons, more.
2 tape set, 1 hour 47 minutes total, Color & B/W VHS video. $35.95 code:MOV2

THE MONTAUK TOUR II

Preston B. Nichols' second companion video to the Montauk books, a popular series about real life time travel. The most in depth and bizarre look at Montauk yet.

NARRATED BY PRESTON B. NICHOLS

THE MONTAUK TOUR II

Video
with Preston B. Nichols

Take a closer look at secret underground military base at Montauk, Long Island, New York with Montauk series author Preston B. Nichols. Preston explores the alleged Time Travel experiements done at Montauk plus footage of the Cardion radar installation at Montauk, an aerial view of Montauk's particle accelerator, an analysis of the 1993 pulse transmissions from the underground base, bizarre footage of an "interdimensional beast," a close look at the Tesla inspired Zero Time Generator, allegedly used in secret Time Travel experiements, more.
2 hour video. Color VHS format. $39.95. code: MT2V

ENTER DARKNESS: ENTER LIGHT

Documentary

This is the video to go along with the popular book 5-5-2000: Ice the Ultimate Disaster by Richard Noone. Noone himself is interviewed extensively in this video on a possible poleshift and resulting cataclysms predicted to occur on May 5, 2000 because of a rare planetary alignment and an unstable earth. Also in this video is material on the construction of the Great Pyramid of Egypt and the evicence for ancient cataclysms. In depth interviews with geologists, astronomers, psychics, and futurists give sound advice on the coming earthchanges and radical change that is predicted in the near future. Interviews with Richard Noone, David Hatcher Childress, Jean Houston, Richard Kieninger, Dolores Cannon, Annie Kirkwood, Dr. Gay Luce and more.
110 minutes. VHS video. $25.00. code: EDLV

The Second Coming of Science

Brian O'Leary, Ph.D.

THE SECOND COMING OF SCIENCE

with Brian O'Leary, Ph.D.

Former astronaut O'Leary, author of Exploring Inner & Outer Space, takes the readers of his books on a visual tour through the new science with a look at Sai Baba, the Face On Mars, Marcel Vogel on crystals, crop circles, object materializations, more.
90 minutes on VHS video cassette. American NTSC format only. $29.95. code: SCSV

NEW VIDEOS

UFOs:
Secrets of the
Black World

The U.S. Govt's Top Secret
UFO Research Program

UFOS: SECRETS OF THE BLACK WORLD

The U.S. Govt's Top Secret UFO Research Program
This German documentary, in English, delves into the secret world of Area 51 in Nevada and the various claims that the US Government is making flying discs with Anti-Gravity Technology. Featured are Bob Lazar on crashed extraterrestrial saucers, interviews with security personnel, video footage of unexplained craft over Groom Lake, more.
135 minutes on VHS video cassette. $39.95. code: UBWV

THE GRAND DECEPTION

UFOs, Area 51 & the U.S. Government
A secret international government plans to stage an extraterrestrial event to bring about a New World Order, an ominous totalitarian system long prophesied, according to Hayakawa, in this startling video. Norio Hayakawa has led expeditions to the supra-secret test facility in Nevada and shows many different clips of anomalous craft over the desert.
100 minutes on VHS video cassette. $29.95. code: GDV

UFOs
&
UNDERGROUND BASES

BILL HAMILTON

UFOS: THE SECRET EVIDENCE

With Michael Heseman
This award-winning German documentary, in English, has probably the largest collection of UFO films and photos than any other documentary. You will see old home movie footage of flying saucers right up to the most recent and controversial UFO cases. Don't miss the daylight footage of a flying saucer flying around a Pan Am jet, 44 original UFO film clips, plus interviews with Russian Cosmonaut Marina Popovich, Bob Lazar, more.
110 minutes on VHS video cassette. $39.95. code: USEV

UFOS & UNDERGROUND BASES

with Bill Hamilton
An unusual presentation on the super-secret Dulce, New Mexico underground UFO base and the alleged extraterrestrial involvement with the military in this area of northern New Mexico and southern Colorado. Is the Dulce Base the origin of the many mysteries of mutilated cattle and other phenomena in the San Luis Valley? Aerial photography of other facilities in southern California, more.
120 minutes on VHS video cassette. $29.95. code: UUBV

SEEKING
THE
STONE

TERRENCE McKENNA

THE NAKED TRUTH

Exposing the Deceptions About the Origins of Modern Religions
with Bill Jenkins, Jordan Maxwell, Derek Partidge
Two riveting hours of revelations on comparing the sacred texts of the Hindus Sumerians, Persians and Egyptians. Discover the astrological and mythical symbols from ancient Egypt and earlier civilizations such as the virgin births of Krishna, Mithra, Osiris and Jesus. How Sun worship was transformed into the Son worship of today, the suppression of thought such as the Inquisition, more.
120 minutes on VHS video cassette. $29.95. code: TNTV

THE
NAKED
TRUTH

Modern Religions

Bill Jenkins
Jordan Maxwell
Derek Partridge

SEEKING THE STONE

Mind & Time ▪ Spirit Matter
with Terrence McKenna
Techno-Shaman Terrence McKenna, author of Timewave Zero, True Hallucinations and others shows us a spiritual path that includes everyone. He champions the individual's freedom of choice in deciding one's own sexual and spiritual development and techniques. He highlights the role of hallucinogenic plants in shamanic societies and their impact on the evolution of human cultures. Complete with special visual effects, see why this cyber-techno-shaman is drawing free-thinking crowds wherever he speaks.
105 minutes on VHS video cassette. $29.95. code: STSV

Please use item codes when ordering http://www.azstarnet.com/~aup

VIDEOS

Extraterrestrial Archaeology: The Video

ADVENTURES UNLIMITED

Journey to strange and fascinating worlds.

EXTRATERRESTRIAL ARCHAEOLOGY:

The Video

David Hatcher Childress lectures with slides about pyramids on the moon, domed cities, other unusual features on the moon, pyramids and other structures on Mars, structures on the various moons and planets of our solar system, why some planets and moons may be hollow. Childress discusses the allegations that NASA may have faked some of the Apollo photos, a space base for UFOs on Mars, more.

1 Hour video. VHS. $24.95. code ETAV

LOST CITIES & ANCIENT TECHNOLOGY

David Hatcher Childress in Conference

Lost Cities series author David Hatcher Childress is presented in conference from Sydney, Australia. Showing hundreds of rare slides, Childress discusses ancient civilizations; Atlantis & Mu; Vimana aircraft technology; past cataclysms; future earth changes; an Egyptian city in the Grand Canyon; archaeological cover-ups and more. Journey with David to a sunken city in the Pacific, see the mysterious ruins of Tiahuanaco, Easter Island and central America. A fascinating and visual tour of Lost Cities and Ancient Mysteries.

3 hours. VHS video. $21.95. code: LCTV

LOST CITIES VIDEO SCRAPBOOK

With David Hatcher Childress

This hour long compilation of material takes us around the world to the mega-lithic sights and lost cities with author-adventurer David Hatcher Childress. Included are interviews with David, discussions with Thor Heyerdahl on Atlantis & sunken cities, South American ruins, cataclysms of the past and future, the lost continent of Mu and more!

110 minutes. VHS. $14.95 code: LCVS

UFOS AND STAR WARS

VHS Video

This two hour long compilation of various rare material begins with a close examination of German anti-gravity & free energy technology of World War II and then moves on to the modern day Star Wars program and look at how there is apparently a literal "battle for earth" going on around us. You will be amazed at footage in this video: close-up photos of German flying saucers with cannons mounted underneath them; NASA footage of Earth's military government shooting Star Wars weapons at UFOs; diagrams of German spaceships built during World War II, news reports of secret "anti-gravity craft" being built in the Nevada desert, and more! In addition, such topics such as the Martian Pyramids, secret bases on the Moon, German bases in Antarctica & South America, the building of a Death Star around this planet, and more.

120 minutes. VHS. Color and B&W $19.95 code: USWV

BRUCE CATHIE IN CONFERENCE EXPLAINING THE WORLD GRID

With Captain Bruce Cathie

New Zealand author and pilot Bruce Cathie on UFOs, the World Grid System, harmonic mathematics, Martian Pyramids, the Harmonics of the Moon, Anti-Gravity and Free Energy. He is the author of the underground best selling books THE ENERGY GRID and THE BRIDGE TO INFINITY and THE HARMONIC CONQUEST OF SPACE. In this video he explains his light-harmonic grid system, how antennas are used in this system, how various governments are already using a fantastic technology, UFO bases in New Zealand and Australia, more.

3 Hour video. VHS $29.95 code: BCV

24 hour credit card orders – call: 815 253 6390 ▪ fax: 815 253 6300 ▪ Email: aup@azstarnet.com

ANCIENT SCIENCE

TZOLKIN
Visionary Perspectives and Calendar Studies
John Major Jenkins

TZOLKIN is a visionary journey into the heart of an ancient oracle. Jenkins, in both academic and mystical viewpoints, explore the sacred Calendar of Mezoamerica is than a calendar, but an ancient cosmology that includes a mytho-evolutionary system which describes the spiritual and physical unfolding of the Earth. At the heart of this sophisticated philosophy is the Sacred Tree—the Axis Mundi. Prepare for a journey... prepare to to enter the mysterious borderland between night and day!

346 pages. 6x9 tradepaper. Profusely illustrated. $13.95. code: TZO

THE AMAZING SECRETS OF THE MASTERS OF THE FAR EAST
by Victor Simon Perara

Learn one of the most carefully guarded secrets of the Adepts of ancient India—how to prolong life while retaining youth, health, and virility. This book reveals how you can achieve prolonged life for yourself through ancient, secret breathing techniques that are given in a simplified form. Learn how to increase mental power, attract what you desire, awaken miraculous abilities, such as telepathy and astral projection, and more importantly, bless yourself with serenity and wisdom.

95 pages, 5x8 tradepaper, $8.95 code: SOM

SEEKERS OF THE LINEAR VISION

Including the Science of Ley Hunting Paul Screeton and Donald Cyr The latest large format book from Stonehenge Viewpoint. Covered in this book are such topics as the history of Ley Hunting; Spirituality and the Power Grid theory; Stone Circle Power; Sacred Geometry; Megalithic Alignments; A New Megalithic Key in Scotland; Alfred Watkins and the Old Straight Track, Tony Wedd and the UFO connection; John Michell's "View Over Atlantis";

25 chapters in all. 128 pages, 10x12 tradepaper. Illustrated with photos, maps & drawings. Index. $12.95. code: SLV

INDRA GIRT BY MARUTS
Electrical Phenomena in the Rig Veda
Jerry Ziegler

Jerry Ziegler second book after YHWH, INDRA GIRT BY MARUTS, uses the Rig Veda to demonstrate the nature of earlier times when the divine manifested through electrical phenomena at anient rites. As God the Father the divine emanated in St. Elmo's Fire on the mountain tops. As the Holy Ghost the divine light shown in the Ark of the Covenant in the temples below in the cities. As both these forms of the divine failed at the end of the earlier era the priesthoods needed a Savior which they found in the Son. For all those interested in ancient electrics and technology.

277 pages. 6x9 Tradepaper. Bibliography. $12.95. code: IGM

MEGALITHIC ADVENTURES
by Donald L. Cyr

Donald Cyr, Stonehenge Viewpoint editor, chronicles his travels and explorations across France, Britain, Wales, Scotland, and Ireland in search of the awesome science of the ancients and the purpose of their megaliths. Heavily illustrated, it also includes chapters on the megalithic monuments of Malta, equinox declination charts, the twelve megalithic patterns computerized with computer analysis of alignments and Cyr's "Halo Patterns."

160 pages, 10x12 tradepaper, with index. Illustrated with 100s of photos, maps and line drawings, $12.95 code: MEGA

Please use item codes when ordering http://www.azstarnet.com/~aup

CONSPIRACY & HISTORY

The National Insecurity Council

IT'S A CONSPIRACY!
The Shocking Truth About America's Favorite Conspiracy Theories
by The National Insecurity Council

A great rundown of over 60 conspiracy theories. Included are chapters on World War II conspiracies, including the SS and the CIA, Rheinhard Gellen, Operation Paperclip, how the Allies created a false Cold War and arms race against the Soviets, Bush's early CIA years, and more. Discussed in detail are the assasinations of JFK, RFK, MLK, Malcolm X, Oswald and others. Nazi-CIA-banking connections, banking conspiracies, media cover-ups, Saddam Hussein and the Gulf War, the story behind the Red Menace, and more shocking information.
252 pages, 6x9 tradepaper. $9.95. code: IAC

BLACK HELICOPTERS OVER AMERICA
Strikeforce for the New World Order
by Jim Keith

Veteran UFO investigator and conspiracy buff Keith's book on the rash of "black helicopter" incidents in America. Keith starts with an overview of "black helicopter" incidents starting in 1971. Many of these incidents are curiously related to cattle mutilations in the same area at the same time. Delves into such topical subjects as black choppers and UFOs; the building of network of concentration camps by the U.S. government; U.N. troop movements reported across America; FEMA as the cover for a police-state; more.
155 pages, 6x9 paperback. Illustrated with maps, photos and diagrams. $12.95. code: BHOA

BLACK HELICOPTERS OVER AMERICA
Strikeforce for the New World Order
JIM KEITH

CONSPIRATORS' HIERARCHY:
The Story of the Committee of 300
Dr. John Coleman.

This documented book is about a powerful group of International Bankers, Industrialists and Oil Magnates trying to control the world. Chapters include information on past and present institutions involved with the so-called Committee of 300 as well as Legal Associations and banks that were or are now under their control. Includes an index and a table of the Committe of 300 in the back.
288 pages, 6x9 tradepaper, illustrated, with index. $16.95. code: CHR

THE GEMSTONE FILE
edited by Jim Keith

with commentaries by Robert Anton Wilson, Kerry Thornley, Len Bracken

Since 1975, conspiracy researchers have circulated A Skeleton Key to the Gemstone File, a document detailing sinister connections and murderous international plotting since the turn of the century. The Skeleton Key links some of the most famous figures and institutions of our time, including Howard Hughes, the Kennedys, the Mafia and the CIA. It also sheds new light on pivotal historical events like the Kennedy assassination and Watergate. With commentaries from a dozen famous conspiratologists and information from the editor of the original Skeleton Key.
224 pages, 6x9 tradepaper. ISBN 0-9626534-5-4, $14.9. code: TGF

PROJECT SEEK
Onassis, Kennedy and the Gemstone Thesis
Gerald A. Carroll

This thick new volume on the famous Gemstone Files is complete with additional research and photos! With the passing of Jackie Onassis-Kennedy, the Gemstone Thesis on the Mafia & the CIA, the formely "Hughes" controlled Defense Industry, and the violent string of murders that have plagued American politics since the 50s. The last chapters contain important new information on the Nugan Hand Bank, the BCCI scandal, "the Octopus," and the Wilcher Transcripts.
388 pages, 6x9 tradepaper. Illustrated with diagrams and photos. $16.95. code: PJS

DEFRAUDING AMERICA
Dirty Secrets of the CIA and other Government Operations
Rodney Stich

The latest thick exposé on the CIA and the Secret Government. With solid evidence Stich details the underhanded operations of the Nugan Hand Bank, the BCCI, CIA and DEA drug trafficking, the October Surprise Cover-up, Inslaw and the Promis Software for Big Brother, Israel and the Mossad, and more. Portions of the book go into details of Gunther Russbacher's Blackbird SR71 Spyplane flight with George Bush to Paris, the Wilshire Documents, more.
654 pages. 6x9 Tradepaper. Illustrated with Index. $25.00. code: DFA

Please use item codes when ordering http://www.azstarnet.com/~aup

ARKTOS:
The Myth of the Pole in Science, Symbolism, and Nazi Survival
Joscelyn Godwin.

Arktos begins with accounts of an Golden Age, and then proceeds to investigate the tilt of the earth's axis, and the causes of catastrophes. Explored are the many tales of an ancient race said to have lived in the Arctic regions, such as Thule and Hyperborea. Progressing onward, the book looks at modern polar legends: including the survival of Hitler, German bases in Antarctica, UFOs, the Hollow Earth, and the hidden kingdoms of Agartha and Shambala This scholarly treatment of a controversial subject also uses extensive foriegn-language sources.
220 pages, 6x9 tradepaper, highly illustrated. $14.95. code: ARK

EMERALD CUP—ARK OF GOLD
The Voyages of Jesus & Joseph of Arimatea to England & the Quest of SS Lt. Otto Rahn of the Third Reich
Col. Howard Buechner

This book chronicles the voyages of Jesus and Joseph of Arimathea to England, and of the Emerald Cup, the Holy Grail of legend. In this book, Buechner traces the legend of the Holy Grail, including exactly what it is and where it came from, King Arthur, King Solomon's treasure, Rennes-le-Château, and the strange quest of a German SS officer to a remote castle in the Pyrenees Mountains of France.
253 pages,7x9 tradepaper, Illustrated. $15.95 code: EMC

ADOLF HITLER & THE SECRETS OF THE HOLY LANCE
Col. Howard Buechner & Capt. Wilhelm Bernhart

One of the most incredible books on lost treasure, secret societies, ancient relics and WW II ever written. Taking up where THE SPEAR OF DESTINY by Trevor Ravenscroft leaves off, this book relates that the Holy Lance was secretly taken to a base in Antarctica, while a replica was returned to the Vienna Museum. A book packed with strange information on Nazi bases in Antarctica, Himmler and the SS, U-boats carrying important Nazis to South America and Hitler's secret treasure.
223 pages, 7x9 tradepaper, 86 photos, maps & illustrations. $15.95. code: SHL

HITLER ASHES
Col. Howard Buechner & Capt. Wilhelm Bernhart

The sequel to SECRETS OF THE HOLY LANCE. Contains information on the death of Hitler, escape routes used by the Nazis, U-boat convoys after the war, Nazi bases in Antarctica, and the secret mission to recover the Lance and Hitler's secret treasure.
290 pages, 7x9 tradepaper, 86 photos, maps & illustrations. $15.95. code: HITA

THE IMMACULATE DECEPTION
The Bush Crime Family Exposed
Russell S. Bowen

This book is perhaps the most shocking book written this century about treason committed by the highest leaders within the U.S. Government. The author tells of his "drug running" activities in behalf of the "secret government." Learn about the unsavory past of George Bush and his family. The book explores these serious questions. Where was George Bush: when the Bay of Pigs fiasco was planned and executed?; when John F. Kennedy, Martin Luther King and Robert F. Kennedy were assassinated?; when Ronald Reagan was nearly assassinated in Washington by a known Bush family associate?; Says the author, "Don't ask George Bush to answer the above questions. He's more acquainted with deniability than telling the truth."
210 pages, 5x8 tradepaper, $12.95. code: TID

CHAOS IN AMERICA
John L. King

This book provides a historical background for the coming depression and collapse of the America economy. Chapters are on Industrial Capitalism and Financial Capitalism; the Practice of Usury; National Bankruptcy; a new kind of debt free money; Last-ditch survival guide; more.
237 pages, 6x9 tradepaper. Illustrated with charts & diagrams. $11.95. code: CIA

24 hour credit card orders – call: 815 253 6390 ▪ fax: 815 253 6300 ▪ Email: aup@azstarnet.com

303 Main Street
P.O. Box 74
Kempton, Illinois 60946
USA
Tel.: 815-253-6390 ♦ Fax: 815-253-6300
Email: adventures_unlimited@mcimail.com

Please check: ✓

☐ This is my first order ☐ I have ordered before ☐ This is a new address

Name			
Address			
City			
State/Province		Postal Code	
Country			
Phone day		Evening	
Fax			

Item Code	Item Description	Price	Qty	Total
CAT	Adventures Unlimited Catalog	N/C		N/C

Please check: ✓

☐ Postal-Surface
☐ Postal-Air Mail (Priority in USA)
☐ UPS (Mainland USA only)

Please Use Item Codes!

Subtotal ➤	
Less Discount-10% for 3 or more items ➤	
Balance ➤	
Illinois Residents 7% Sales Tax ➤	
Previous Credit ➤	
Shipping ➤	
Total (check/MO in USD$ only) ➤	

☐ Visa/MasterCard/Discover/Amex

#_____ Exp. ____

Comments & Suggestions

Share Our Catalog with a Friend

10% Discount When You Order 3 or More Items!